Eduardo Paolozzi

Cover illustration from *Zero Energy Experimental Pile: Will the Future Ruler of the Earth come from the Ranks of the Insects?* 1969–70 offset lithograph and screenprint (edition of 125) 34 × 24 in. Published by the Petersburg Press, London, 1970

Eduardo Paolozzi

Diane Kirkpatrick

New York Graphic Society Ltd.
Greenwich, Connecticut

ILLUSTRATION ACKNOWLEDGMENTS
Plates 2, 4, 6, 7, 9, 11, 19, 20, 25, 30, 31, 32, 33, 34, 35, 40, 53, 69, 70, 71, photos
by David Farrell; plates 3, 5, 14, 15, 18, 26, 27, 76, 78, photos by A. C. Cooper;
plates 10, 12, 13, photos by Nigel Henderson; plates 21, 29, 72, 74, 79, 80,
83, 84, photos by Deste Photography; plates 23, 77, photos by the author;
plates 24, 47, 52, 59, 75, photos by John Webb; plates 39, 41, 42, 44, 46, 48,
49, 51, 54, 55, 57, 60, 61, 65, 67, photos by Tudor Photos; plates 45, 56, 58, 62,
68, photos by Howard's Studio; plate 50, photo by Akihiru Ishikawa;
plate 64, photo by Hugh Gordon; plates 85, 86, 87, photos by Tamie Swett.

International Standard Book No. 0-8212-0226-X
Library of Congress Catalog Card No. 71-125993

Published in Great Britain
by Studio Vista Limited, London
and in the United States of America
by New York Graphic Society Ltd.,
Greenwich, Connecticut 06830
Designed by John Lewis
Set in 10 on 12 point century Schoolbook
Printed in the Netherlands by NV Grafische Industrie Haarlem

Contents

Preface

Eduardo Paolozzi's significant creations in the fields of sculpture, graphic arts, film, and writing have earned him a widespread international reputation. In this brief text I have attempted to present the major ideas and styles of his career to date. The artist firmly believes in maintaining a strict separation between his personal and his professional life; therefore, I have only mentioned biographical facts which have a direct bearing on his work.

This book developed out of work done for my Ph.D. dissertation (*Eduardo Paolozzi: A Study of His Work 1946–1968*), presented at the University of Michigan in 1969. Much of the research for that paper was done in England during 1967–8. The collection of information would have been impossible without the encouragement and help of innumerable people. At the University of Michigan, I am especially indebted to Professor Marvin J. Eisenberg who supported my desire to write on Paolozzi, to Professors Harold E. Wethey and Nathan T. Whitman who taught me much about the method and value of careful scholarship, and to Professors Victor H. Miesel, Joel Isaacson, and Chet H. LaMore who, with endless patience, exchanged ideas on the artist and his work. In New York, thanks go to Mr Arnold Glimcher, Mr Fred Mueller, and Miss Judith Harney of the Pace Gallery and to Miss Virginia Allen of the Department of Drawings and Prints at the Museum of Modern Art. In England, thanks go to Mrs Lilian Somerville and the staff of the Fine Arts Department of the British Council, especially to Miss Margaret McLeod who 'opened many doors' and to Mrs Grace Hodgkinson, Mrs Iris Allen, Miss Joan Cousins, and Miss Rita Small for help in matters of documentation and data; to Miss Erika Brausen and the staff of the Hanover Gallery; to Mr Joseph Studholme and the staff of Editions Alecto; to the staff of the Circulation Department of the Victoria and Albert Museum; to F. M. L. Walmsley and the staff of the Tate Gallery; and to those individuals who generously shared their time and knowledge in personal interviews: Mr Christopher Finch, Mr Richard Hamilton, Mr James Kirkwood, Mr Robert Melville, Mr Michael Middleton, Mrs Dorothy Morland, Mr Francis Morland, Mr Christopher Prater, Alison and Peter Smithson; and especially to Miss Jane Drew, to Mr and Mrs Nigel Henderson, to Mrs Gabrielle Keiller, to Mr and Mrs Fred Mayor, and to Mr and Mrs Colin St John Wilson, all of whom freely opened their homes and their collections to me.

6

Finally, and most important of all, this study could not have been written without the full co-operation, inspiration, and help of Mr Eduardo Paolozzi.

<div align="right">
DIANE KIRKPATRICK

1969
</div>

Chronology

MAJOR CAREER DATES

1924 Born in Leith, Edinburgh, Scotland.

1943 Studied at Edinburgh College of Art.

1945–7 Studied at Slade School of Art, Oxford and London.

1947–9 In Paris; made the acquaintance of Giacometti, Dada, and Surrealism.

1949–55 Taught textile design at Central School of Arts and Crafts, London. Worked on various commercial commissions and architectural projects, including one sculpture and one fountain for the Festival of Britain in 1951 and three large fountains for a park in Hamburg in 1953.

1952 British Critics' Prize.

1953 Finalist in competition for the 'Unknown Political Prisoner', sponsored by the Contemporary Art Society, London.

1955–8 Taught sculpture at St Martin's School of Art, London.

1956 Norma and William Copley Award.

1960–62 Visiting professor to advise on sculpture and basic design at the Staatliche Hochschule für Bildende Künste, Hamburg, Germany.

1960 Award for the Best Sculptor Under 45; given by the David E. Bright Foundation at the 30th Venice Biennale.

1967 Purchase Prize, International Sculpture Exhibition, Solomon R. Guggenheim Museum, New York. First Prize for Sculpture, Carnegie International Exhibition of Contemporary Painting and Sculpture, Pittsburgh.

1968 Visiting Professor of Art at University of California, Berkeley.

1968 — the present: teaches in Ceramics Department of Royal College of Art, London.

The artist works in London and lives in Essex with his wife (he married in 1951) and three daughters.

ONE MAN EXHIBITIONS

1947 London. 'Drawings and Sculptures by Eduardo Paolozzi', Mayor Gallery; 14 January–1 February.

1948 London. 'An Exhibition of Recent Drawings', Mayor Gallery; 3–21 February.

1949 London. 'Drawings and Bas-Reliefs', Mayor Gallery; 10–31 May.

1958 London. 'Sculpture', Hanover Gallery; 11 November–31 December.

1960 New York. Betty Parsons Gallery; 14 March–2 April.
Venice. Retrospective, British Pavilion, 30th Venice Biennale; summer 1960. After the Biennale closed, the show travelled to Belgrade; Paris; Bochem; Brussels; Oslo; Louisiana, Denmark; Amsterdam; Baden-Baden; and Tübingen.
Manchester. Manchester City Art Gallery; October.

1962 New York. Betty Parsons Gallery; 23 April–12 May.

1963 London. The Waddington Galleries; 5–28 September.

1964 London. 'Recent Sculpture and Collage', Robert Fraser Gallery; 15 September–18 October.
New York. 'Sculpture', Museum of Modern Art; 21 September–10 November.

1965 Newcastle-upon-Tyne. 'Recent Sculpture, Drawings, and Collages', Hatton Gallery, The University of Newcastle-upon-Tyne, 8 February–6 March.
London. 'Sculptures, Collages, Graphics', Gallery of the Chelsea School of Art; 3–26 May.
London. *As Is When*, Editions Alecto; 4 May–5 June.

1966 New York. 'Recent Sculpture', Pace Gallery; 8 January–2 February.
London. 'Recent Sculpture', Robert Fraser Gallery.
Edinburgh. 'Sculpture, prints', Scottish National Gallery of Modern Art; 9 April–8 May.

1967 London. 'Sculpture and Graphics', Hanover Gallery; 14 June–21 July.
Otterlo, Holland. Rijksmuseum Kröller-Müller; 7 May–2 July.
London. *Universal Electronic Vacuum*, Alecto Gallery; November.
New York. Pace Gallery; 18 November–16 December.

1968 Berkeley, California. 'Eduardo Paolozzi: A Print Retrospective', Worth Ryder Art Gallery, University of California, Berkeley; 15 May–9 June.
Amsterdam. 'Eduardo Paolozzi: Silk Screens', Print Cabinet, Stedelijk Museum; 24 May–30 June.

1968-9 Düsseldorf. 'Plastik und Graphik', Städtische Kunsthalle; 19 November 1968–1 January 1969.
1969 Stuttgart. 'Plastiken, Graphik', Württembergischer Kunstverein; 30 January–9 March.
Berlin. 'Complete Graphics', Galerie Mikro (in collaboration with Petersburg Press, London); spring.

IMPORTANT SMALL GROUP EXHIBITIONS

1950 London. 'Kenneth King, Eduardo Paolozzi, and William Turnbull', Hanover Gallery; 21 February–18 March.
1952 Rome. 'Adams, Blow, Paolozzi, Pasmore', Galleria Origine; 8–31 March.
1956 London. 'Contemporary Sculpture', Hanover Gallery; July–September.
1957 Cambridge. 'Eduardo Paolozzi, Nigel Henderson', The Arts Council Gallery; 28 February–16 March.
1959 Cambridge. 'Class of '59: Paintings, Sculptures, Collage — Magda Cordell, Eduardo Paolozzi, John McHale', The Union, Cambridge University; 1–19 February.
1966 Milan. 'Blake, Boshier, Caulfield, Hamilton, Paolozzi', Studio Marconi; June.

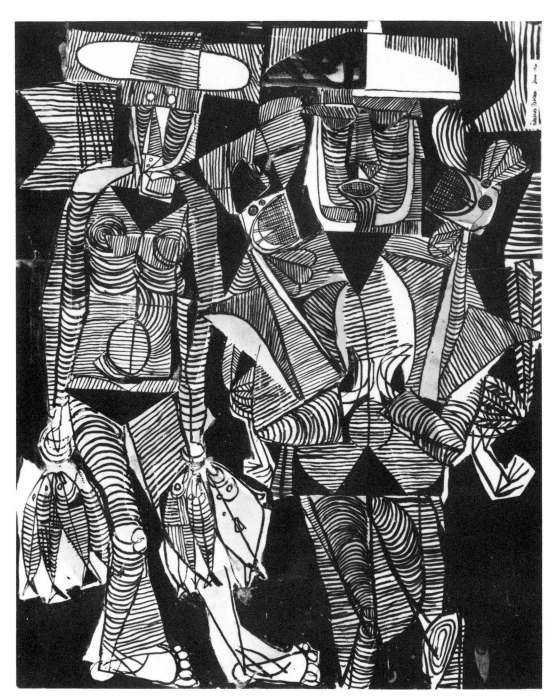

1 *Fisherman and Wife* 1946, ink, wash and collage, $30\frac{1}{4} \times 24$ in.
Tate Gallery, London

Eduardo Paolozzi: the formative years

Eduardo Paolozzi is one of the major image-makers of our age. Despite the fact that he has many times virtually re-invented his graphic and sculptural styles, certain key ideas have reappeared in different guises in each stylistic phase. Perhaps the central unifying concept which has underlaid his work from his student days to the present is the desire to express the quality of mystery, of magic, which he finds present in the ordinary objects and events of the world — what he has called 'the sublime of everyday life'. More recently this has been joined by the desire to express something of 'the schizophrenic quality' of present western urban life.

To accomplish his aims, Paolozzi has devised many techniques for presenting multiple layers of evocative imagery. From the beginning of his career, he has looked at the whole environment, considering past and present 'fine' art as only one segment of a rich multiple life experience. During his student days at the Slade School of Art in London (1945–7), he began the habit of idea collecting which has remained the essential core of his creative process throughout his career. He spent relatively little time in the classroom, preferring to visit various museums and galleries. In the libraries and halls of the Museums of Science and Natural History, he browsed through magazines, prints of old machines, and cases full of man-made and natural objects. In the art museums, he was attracted to work that was intricate and 'busy' like the drawings of Dürer and Rembrandt, Piero di Cosimo's paintings, Byzantine and Gothic ivories, and the surfaces of oriental bronzes. In such works he found 'other ways of handling my own obsession with detail. . . . For me, as for Piero di Cosimo, detail is . . . a world within a world, and then another world within this last world, like a series of boxes in which each box, once opened, reveals in turn another box, and then again another box.' (Roditi, *Dialogues on Art*)

This fascination with detail perhaps helped the young Paolozzi instinctively to approach his work as a collagist. Many early drawings were on sheets pieced together from small paper fragments. Perhaps the process was prompted in these early years by a lack of funds. Perhaps it was also related to the place and the time, for Britain in 1946 was still suffering through lean years which necessitated the continued use of an ingenious make-do-with-what-you-have spirit first bred by the rigours of war. Whatever the original impetus, the young artist early

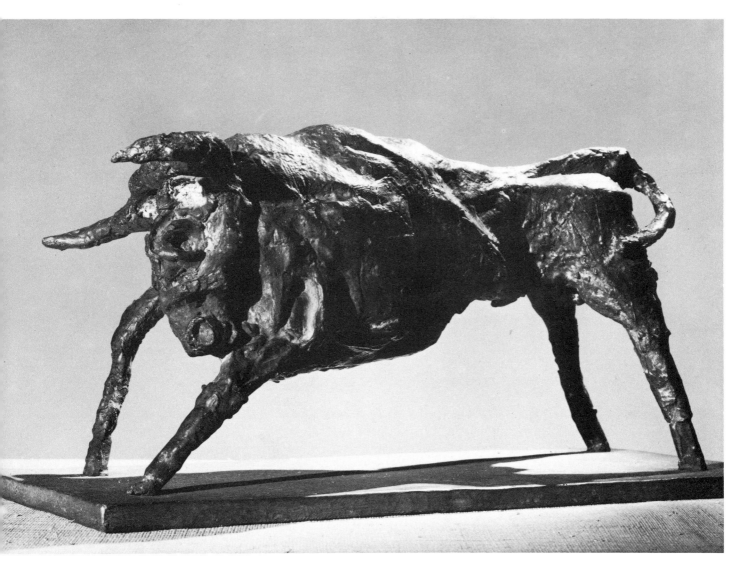

2 *Bull* 1946, bronze, 17¾ in. l.
Private collection

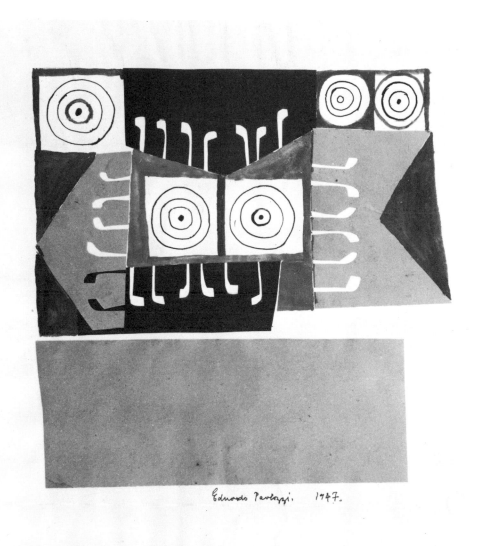

3　*Fair Drawing* 1947, ink, gouache, water colour, coloured paper, 21 × 13 in.
Collection Colin St John Wilson, Cambridge

found multiple collage to be a versatile method both for the collection of
ideas and for their translation into art. From the beginning, he scanned
the world around him for stimuli to be transformed into segments of his
finished work. Many early drawings and sculptures were based on
memories of childhood days near the sea shore. Already he tried, as he

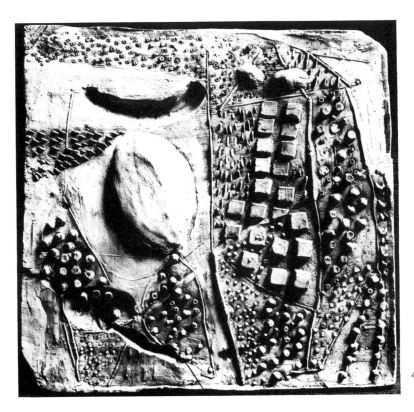

4 *Fish* 1948, plaster, $11\frac{1}{2} \times 11\frac{1}{4}$ in.
Private collection

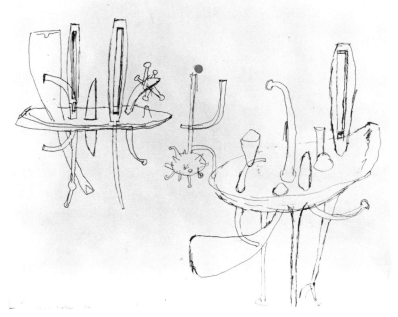

5 *Standing Sculpture* 1949, ink, $14 \times 16\frac{3}{4}$ in.
Collection the artist

later said, 'to achieve a metamorphosis of quite ordinary things into something wonderful and extraordinary that is neither nonsensical nor morally edifying.' (Roditi, *Dialogues on Art*) Animals, gas lamps, and fishermen were turned into magical linear schemata or reduced anatomies of arbitrary structural planes (plate 1).

Most of the early sculptures were in rough concrete, with a brute power and originality of design which inspired a number of young London art students to break away from the refined, smoothly-polished styles of Moore and Hepworth. The force of Paolozzi's early sculpture can be seen in *Bull*, 1946 (plate 2), whose crude technique suggests some of Picasso's sculptures. But the mood of Paolozzi's piece is harsher and its conception is less intellectually ordered than those of Picasso. *Bull*'s rude forms exude brutal, primitive power. Fierce energy travels up the wide-spread rear legs. It sucks in the haunches and roars on, pausing almost to explode in the swelling shoulder muscles before it finds its potential exit in the horn tips and pawing right hoof. The bull's anatomy is not depicted with clinical accuracy; it is suggested by ropey ridges which criss-cross the body, simultaneously incarnating a bold animal spirit and evoking the image of an ancient and rugged landscape.

In the summer of 1947 Paolozzi headed for Paris. There he found rich new fields for idea gathering. He went to museums (especially the Musée de l'Homme and the Conservatoire des Arts et Métiers), and like most young artists in Paris at this period, he was caught up by the art around him. He saw Dubuffet's collection of *art brut*, studied Tristan Tzara's collection of primitive sculpture and modern art, and pored over Mary Reynolds' extensive collection of Duchamp's early works and of Dada and Surrealist documents. He especially admired the works of Miró and Klee. He also met many artists, including Giacometti in whose studio he spent long hours talking and looking. The influence of all these contacts may be seen in much of the work from Paolozzi's Paris period. However, such outside ideas were always put at the service of a developing personal language.

Paolozzi's first works in Paris were collage drawings. The subjects were the street booths of the French National Lottery and the shooting galleries at Paris street fairs. The target and wheel walls at the back of the booths presented lively patterned designs which were marvellous ready-made subjects for an artist 'obsessed with detail'. By reducing selected portions of the booth structures to quasi-geometrical shapes, Paolozzi turned these entertainment machines into a series of personages with giant mask faces (plate 3). These drawings were the first strong statements of Paolozzi's extraordinary ability to find a living spirit in any chosen subject — animate or inanimate. The creation of such presences becomes one of the artist's main devices for communicating 'the sublime of everyday life'. Most Paolozzi personages of the later 1940s were based on animate subjects. In Paris, his contact with Surrealist art

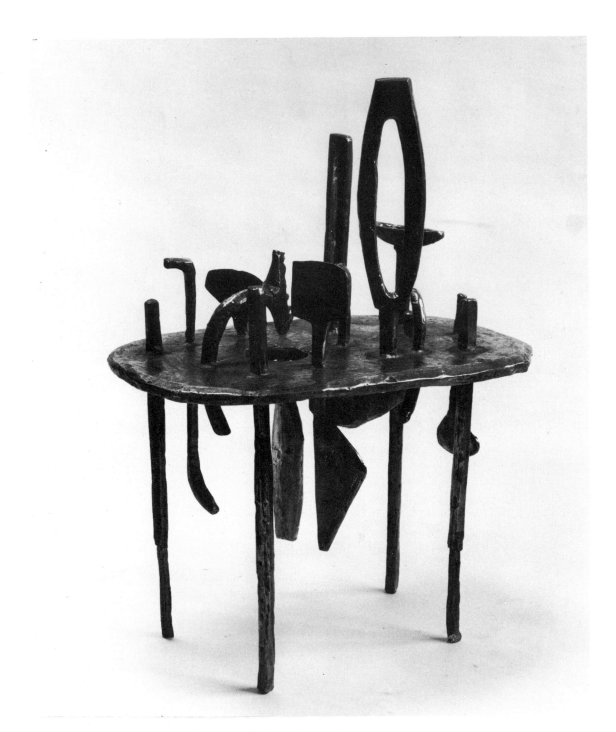

6 *Growth* 1949, bronze (edition of 6), 32 × 23¾ × 16 in.

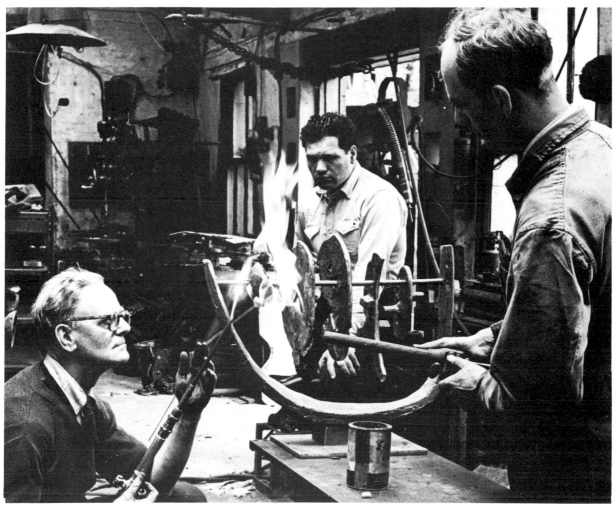

7 Welding *Forms on a Bow No. 2*

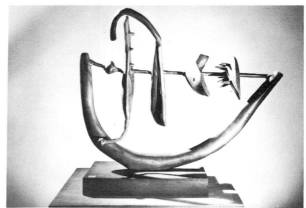

8 *Forms on a Bow* 1949, brass, $19\frac{1}{4} \times 25 \times 8\frac{1}{2}$ in.
Tate Gallery, London

17

and with the work of Paul Klee focused his thoughts on aspects of nature: 'When I went from the Slade directly to Paris, there was all the Surrealist investigation I engaged myself in, and there seems to have been in Surrealism there an engagement with natural history.' (Sylvester, *Britain Today*) Paolozzi's first 'nature' works in Paris were plaster bas-reliefs. Many of them suggested watery dream worlds in which biomorphic shapes were embedded within a patterned environment which seemed like a whole segment of beach or ocean floor (plate 4).

In late 1948 and 1949, Paolozzi produced two series of free-standing metal sculptures. One was a group of table sculptures like *Growth*, 1949 (plate 6), in which magical botanical dramas seem to unfold before the viewer's eyes. Suggestive biomorphic shapes pierce horizontal planes to form gatherings of strange personages above and below the 'stage-ground'. The images may have been partly inspired by cut-away botany exhibits in the London and Paris museums of natural history, but the table sculptures also emit a supernal resonance which recalls the visions of Klee and Ernst, Miró and Giacometti. The second series of metal sculptures developed tensions between impaled forms suspended on single rods in space. The shapes of *Forms on a Bow*, 1949 (plate 8), combine the appearance of organic and mechanical forms. The bow looks like a weapon, yet the bulges in its curving body fill it with a sense of pulsating life. The forms hung on the bow-string are similar blends of the biological and the man-made. The larger forms resemble live musical instruments, while the smaller shapes combine the appearance of an insect or sea creature with the stiffness and arbitrary sleekness of the machined object.

The metal sculptures of the late 1940s were Paolozzi's most ambitious and mature early works. Although he used a traditional plaster-to-metal technique (plate 7), he produced highly original images whose compositions established complex inner tensions which arouse the viewer's kinaesthetic sense. Sculptures like *Forms on a Bow* have stretched-out, shallow compositions which stress the interrelationship of their juxtaposed shapes. The visual impact is not unlike that of a ballet in which the movements of each dancer are significant and indispensable yet the ultimate meaning comes from the simultaneous motion of all dancers and the total kinetic composition of which each is a part. The effect in some ways resembles the Surrealist-related sculptures of David Smith. Smith, in the 1930s, 1940s, and early 1950s, produced a series of similar biomorphic ideograms in space. However, Paolozzi's work could not long be said to parallel Smith's. For Paolozzi, formal style always was part of his quest for potent ways of achieving 'the metamorphosis of quite ordinary things into something wonderful and extraordinary'.

18

The 1950s

During the first part of the 1950s, Paolozzi devised collage techniques to create a series of presences which embodied the spirit of various total systems (plates 9, 24, 29). As visual metaphors for a variety of natural and man-made 'communications networks', they reflected the interest which was developing in many places at this time in the informal image systems of various macro- and micro-structures. Jackson Pollock's interwoven loops of dripped and spattered paint covered huge canvas fields with overall patterns which seemed to reveal usually unseen energy paths. Artists like Dubuffet specifically cited new sources for their art in descriptive physics, geology, geography, and biochemistry. Possibly the new interests were partially stimulated by the cross-disciplinary investigations connected with the new field of cybernetics. Certainly, in the arts, it was also reinforced by several photo books which explored aspects of the world hitherto mostly invisible. Moholy-Nagy's *Vision in Motion*, Thompson's *Nature and Form*, Ozenfant's *Foundations of Modern Art,* Gutkind's *Our World From the Air,* and Kepes' *The New Landscape* each presented different aspects of the new visual frontiers which Kepes described as 'magnification of optical data, expansion and compression of events in time, expansion of the eye's sensitivity range, and modulation of signals'. (Kepes, *The New Landscape*) In 1953 Paolozzi and four friends — Nigel Henderson, Ronald Jenkins, and Alison and Peter Smithson — expressed their personal excitement in part of their written 'Statement of Purpose' for their large photographic exhibition 'Parallel of Life and Art' at the Institute of Contemporary Arts:

> Technical inventions such as the photographic enlarger, aerial photography and the high speed flash have given us new tools with which to expand our field of vision beyond the limits imposed on previous generations. Their products feed our newspapers, our periodicals and our films, being continually before our eyes; thus we have become familiar with material and aspects of material hitherto inaccessible. Today the painter, for example, may find beneath the microscope a visual world that excites his senses far more than does the ordinary world of streets, trees and faces. But his work will necessarily seem obscure to the observer who does not take into account the impact on him of these new visual discoveries. (Unpublished manuscript in the collection of Nigel Henderson)

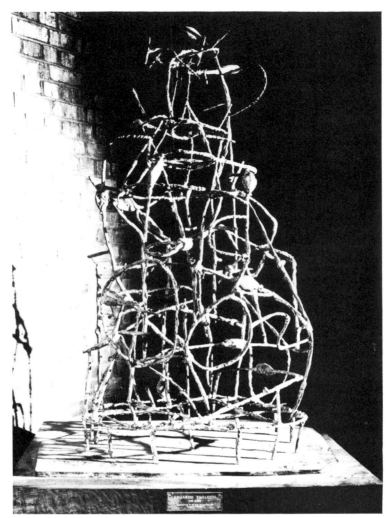

9 *The Cage* 1951, bronze, 6 × 3 × 3 ft
Collection the Arts Council, London

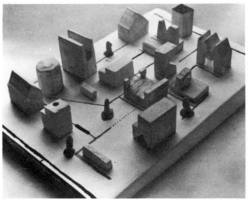

10 Study for a playground for a block
of flats, Whitefoot Lane, London,
c. 1950–51, plaster, wood, cardboard,
and wax for poured concrete, approx.
9 × 38 × 30 in.

In his own work, Paolozzi characteristically sought to express the magic, the quality of the sublime, inherent in the image systems which fascinated him. He produced 'system-presences' in collages, reliefs, and free-standing sculptures. The images have the intricacy and equally-overall patterns of maps, charts, diagrams, plans; yet, they also possess that particular sense of vital *élan* — of living presence — which informs Paolozzi's most personal works. In *The Cage* (plate 9), commissioned for the 1951 Festival of Britain, Paolozzi created a free-standing space-frame filled with such a spirit. Its rough, twisting metal framework seems like a fanciful being born of a union between a climbing vine and a rickety trellis. However, the open form also oddly resembles a figure with flesh stripped away to reveal its central nervous system. The general idea is related to other space-constructions of the late 1940s and early 1950s, some of which echoed external natural forms. However, *The Cage* is one of the few sculptures which succeeded in expressing nature's internal energy networks.

Paolozzi was briefly tempted by certain aspects of *The Cage* and a related work, *Fountain* (also commissioned for the Festival of Britain), to explore the sculptural problems of environment sculpture. Although they lay outside his basic interests, the results of his brief excursion into this field are interesting and significant in themselves. Paolozzi's *Fountain* was a monumental, architectonic space cage. It was conceived as a self-contained unit, but its large scale probably helped stir the artist's interest in working with actual environment sculpture. His experiments with environmental works were probably also partly inspired by his close contact in the early 1950s with architects like Jane Drew and the Smithsons. One of Paolozzi's first environment pieces was conceived for a playground commissioned from him in 1950–51 by the Fry, Drew architectural firm for a block of flats at Whitefoot Lane (plate 10). The project never got beyond the model stage, but the design proposed an imaginative and elaborate child environment in which the surface of a rectangular play field was broken by wandering line and dot divisions reminiscent of city lots and streets. Fifteen varied sculptural shapes were grouped within and across the field like a village of fanciful buildings. Had the project been executed, the sizes and shapes of the final poured concrete forms would have provided a child-sized wonder world of crawl- and climb- and sit- and lie- and jump- and shout- and hide-spaces.

Paolozzi developed his environment concept further in a maquette for the Unknown Political Prisoner International Sculpture Competition, sponsored by the Institute of Contemporary Arts, London, in 1952–3 (plate 21). The model has five moveable 'buildings' resting on a thick slab base. Seven areas on the base are violently cross-scored, creating rough sites for the five structures. Other line patterns on the base suggest a city map, although the placement is too irregular, too casual, too

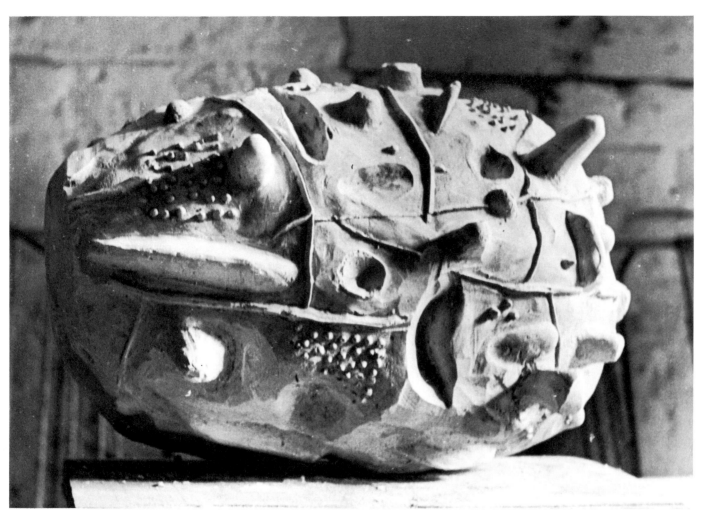

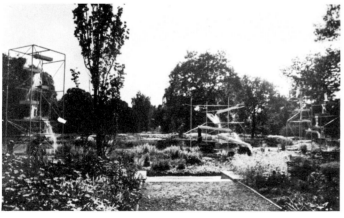

11 *Study for a Larger Sculpture in Concrete, c.*
1951, plaster sprayed with metal (edition of 6),
$16\frac{1}{8}$ in. l.

12 *Three Fountains* 1953, Hamburg,
Germany, steel

unsystematic for any existent city scheme. Incised designs on the four largest buildings paraphrase details of modern high-rise city architecture; the imprecise blocks suggest images of ageing and war-damaged structures. The smallest building in the maquette is dwarfed by the larger blocks. This is the prison tower — within is the unseen Unknown Political Prisoner. The very non-assertiveness of this tower's small size, shape, surface pattern, and colour forces a heightened awareness of its form on the viewer. One full-length nude figure is inscribed into a base panel at the bottom of the tallest building. A second figure is scratched into one portion of the base. The figures perhaps are meant to serve as a scale module like the *Modulor Figure* which Le Corbusier placed on the base of every apartment building he built. But on the Unknown Political Prisoner maquette, the figures also suggest *Massemensch* — the anonymous many who are not literal political prisoners but who remain trapped within the narrow confines of lives over which they have little control.

The meditations aroused by the whole maquette would undoubtedly have been forcefully magnified if the project had ever been executed on the scale for which it was planned. Then one would have had to enter it, become a part of this separate world of a monument to an Unknown Political Prisoner. Some of the other entries in the contest verged on environment sculpture. However, the other works were not multi-units which created an environment experience. Rather, they conveyed the sense of integrated objects, however architectural, to be viewed and grasped as a whole. Paolozzi's was different. He created a group of closed architectonic forms, each a different simple shape, set on a base which unified them into elements of a single work. The space that flowed around and between them reinforced their abstract shape-presences. Had the monument been built, the experience of walking through it would have prophesied the viewer's experience of some environmental sculpture of the 1960s. Paolozzi's last environment work was actually carried out full scale. It was a trio of fountains commissioned for a 1953 garden exhibition in Hamburg, Germany (plate 12). The individual fountains were architectonic structures related to the design of the Festival of Britain *Fountain*. But the Hamburg works were interdependent units, placed with careful attention to their interrelation as structural shapes. The intermediary garden spaces were modulated by the placement, shapes, and sounds of the fountain towers. The whole was to be experienced by the viewer as an outdoor environment.

Interesting (and prophetic) as some of Paolozzi's environment ideas were, he turned away from problems based on total spatial designs. They suited his bent for collage works, but he found little scope in them for the creation of metamorphic presences filled with the sense of mystery, and of the sublime, which is the essential core of his more exciting works. The magic he found in various image-systems was more fruitfully expressed in

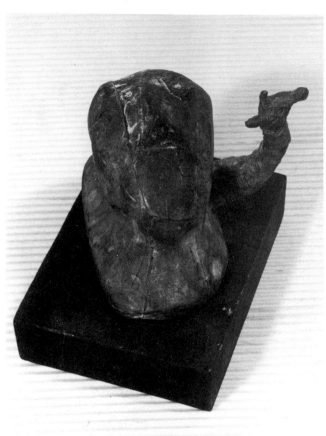

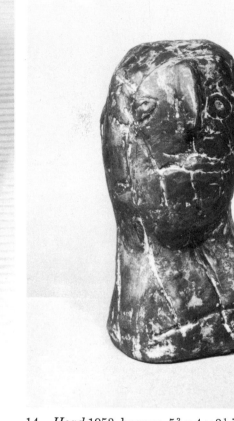

13 *Head and Arm, c.* 1954, bronze, 4¾ in. h.
Collection the artist

14 *Head* 1953, bronze, 5¾ × 4 × 3¼ in.
Collection Colin St John Wilson, Cambridge

a series of collages and reliefs. The collages are mostly based on a non-descriptive, loosely rectilinear order (plate 24). They seem like fantastic architectural plans, or aerial views of earth and city surfaces. Paolozzi created special screenprinted pattern sheets as raw material for his designs. The screenprints became found-objects which he tore into irregular pieces. These he pushed around on a new ground, improvising arrangements and playing with the laws of chance exploited by Dada and Surrealism and picked up in the 1940s and 1950s by artists like de Kooning and Dubuffet. For Paolozzi, serendipity was one key to releasing/creating his hermetic world of images. It was a counterpart in the visual arts to the improvisation of jazz musicians like Thelonius Monk and Dizzy Gillespie (whose works he particularly admired).

24

15 *Head* (*3*) 1953, gouache and monotype, 22 × 17 in. Collection the British Council, London

16 *Man's Head* 1952–3, gouache, crayon, ink, pencil, water colour, $27\frac{1}{2} \times 22\frac{1}{2}$ in. Tate Gallery, London

Improvisation is anti-rigid; it is a fluid, easy, growing form of expression. The hearer (or viewer) can be jarred loose from habitual mental sets to a new freedom which savours multiple simultaneous perceptions.

In the collages of the early 1950s, Paolozzi created a series of hauntingly multi-evocative image-systems. In most of the collages, narrow vertical strips, containing a variety of patterns to establish their shapes, set up lively, irregular pulses as the eye takes in their seemingly random positions across the predominantly horizontal background patterns. Some of the collage elements are cut-out dots or triangles which add exuberant variety to parts of their compositions. Line and dot patterns suggest earth and creature structures, yet are not as static as such images would be on a slide or in a photograph. Paolozzi executed several

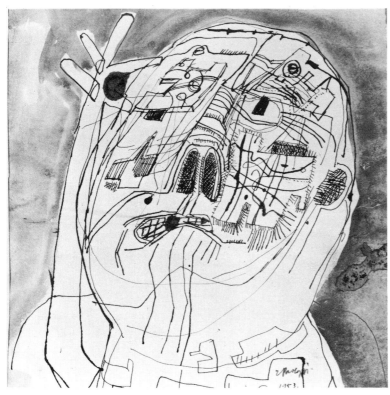

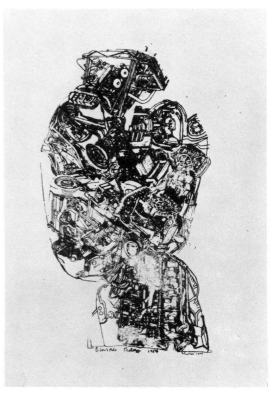

17 *Head* 1953, ink and wash, $10\frac{3}{4} \times 12\frac{7}{8}$ in.
Collection the artist

18 *Automobile Head* 1954, collage, $22 \times$ 15 in. (screenprint editions after this design in 1954, 1957, 1958 and 1963) Private collection

large collage murals in a similar style (plate 29). It adapted beautifully to an architectural setting. Theoretically, the pattern structures of the collages could be extended to any length or height. The designs activated the flat wall surfaces without violating their sense of plane, and the images echoed the spirit of architectural planning while retaining a creative vitality all their own. The mural collages were usually done on large pieces of board, often painted with a cream-coloured ground. Flat silhouettes often contrasted with more delicate, busier, linear topological networks. All Paolozzi's collages have sumptuous colour touches added in opaque and semi-transparent paints and papers. None of the collages can be completely grasped as a visual whole. The eye must wander over the surface exploring the never-static colours, patterns, shapes, relationships which seemingly unfold before the viewer's gaze.

26

The images capture some of the rich, shifting, disordered quality of the modern life experience.

The reliefs were perhaps even more multi-suggestive images than the collages. Surfaces of earlier sculptures like *Fish* (plate 4) had resembled mini-landscapes, but their designs remained primarily depictions of fish, flowers, etc. In the 1950s Paolozzi's relief-landscapes became first more abstract, then more completely and multiply suggestive of air views of both natural and man-made landscapes. Eventually he wrapped such surfaces around free-standing works like *Study for a Larger Sculpture in Concrete, c.* 1951 (plate 11). This work, especially when viewed from above, also resembles a strange horned toad. It is one of the first pieces in which Paolozzi weds his image of a wonder-filled system-scape with a magical natural creature-presence. But it is paralleled by contemporary experiments the artist was making with human images.

His first human-landscapes were heads. (A 1953 London exhibition called 'The Wonder and Horror of the Human Head' may have helped to focus his attention on the expressive possibilities of the head.) In small bronze sculptures like *Head and Arm* (plate 13), he created images of a poignant, elemental humanity. The simplified forms reflected something of Paolozzi's interest in Etruscan sculpture, the works of Marino Marini, and the plaster figures of victims in the museum at Pompeii. The deliberately crude and often brutalized forms were related to *art brut* and to the 'damaged man' themes of artists like Germaine Richier, Francis Bacon, and Willem de Kooning. In some of the heads (plate 14), line grooves crack the surfaces into uneven sections. Both graphic and sculpted heads often were rendered as overall, extremely rough-surfaced masses related to some of the work of Dubuffet (plate 15). But the sense of presence in each piece is Paolozzi's own. The sculptures are all small. All possess at least a head and shoulders, which allowed the artist to create a gesture-pose for each figure fragment. With a minimum of visual details, Paolozzi revealed whole human personalities. He reinforced the character impressions of the small figures by varying cranium shapes, mouth slashes, nose bumps, and eye cavities. Quizzical, defiant, jocular, aware — all shades of human emotions and notions seem revealed here, except that of refinement.

In some drawings, Paolozzi went further and created images which simultaneously suggested the inner and outer regions of a head and the unseen vital forces which give it life. In *Man's Head*, 1952–3 (plate 16), the artist reworked an earlier system-presence head by filling in a background area with body colour and placing a network of black lines over the fine web patterns of the earlier head and neck. The heavier lines delineate the main facial features and trace wrinkles and veins on the horribly transparent outer skin. Beneath lies a teeming world suggested by the undercurrent of lighter lines. Paolozzi wrote of a 'WORLD WITHIN A WORLD. A LANDSCAPE WITHIN A FACE. A RIDGE

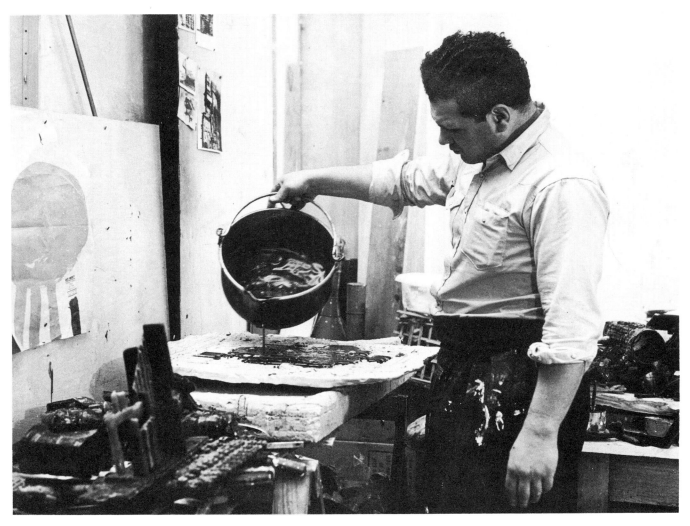

19　The artist pouring wax for one of the found-object style pieces

AND THREE MOUNTAINS SUGGEST A SMILE. . . . COMPLEX
MICROSCOPIC WORLD LIVES IN THE MOUTH.' (Paolozzi, *Uppercase
No. 1*) However, many of Paolozzi's faces suggested more than simple
mixtures of human visages with natural terrain. Identifiably rendered
cameras, templates, musical instruments, cigarettes and smoke, became
extra features of heads and torsos (plate 17). Here were visual **metaphors**
for the mystery of the tool. Created to aid man in performing certain
tasks, tools can remain inert, lifeless, things apart. But if fully mastered

they become vital extensions of man's senses and physical abilities, used with as little conscious thought as actual eyes or hands. Cameras serve as third eyes, trumpets extend voices, (prosthetic devices replace lost limbs). In fact the tool, with the help of hard-sell advertising, has become an inseparable part of the human image. Increasingly the complete man must travel with glasses, watch, binoculars, camera, transistor radio, tape-recorder, etc. Even the cigarette may be considered a tool for creating pleasure, meditation, or sex appeal. Paolozzi, with his fascination for metamorphosis, made a series of drawings of smokers in which cigarettes turn into smoke clouds which merge with and, equally, obscure human features. The slick Madison Avenue image of virile masculine puffers has been passed through a brutalizing filter to arrive at the picture of the real, non-cultured mass-man.

From such images, it was but a step to a metamorphosis in which objects *from* the environment became the collage-skins of the beings *in* that environment. One of Paolozzi's first works with this theme is the 1954 collage *Automobile Head* (plate 18). In it, the artist has filled the head-and-shoulders silhouette with an Arcimboldesque agglomeration of cut-up catalogue illustrations of motor parts. By 1956 Paolozzi had devised a way of translating the imagery of this collage into sculpture. Earlier in the decade he had experimented with a method of incorporating actual objects into the surface of a relief sculpture. However, he found that this method did not give him enough control over the final composition, and the work did not satisfy his desire for permanent sculpture: 'Nothing would disturb me more than to see a few years after completing one of my sculptures, that some of the *objets trouvés* of the epidermis, insignificant though they may seem as details, had become lost.' (Roditi, *Dialogues on Art*) The method Paolozzi finally devised began with the collection of miscellaneous things:

> Here is a list of objects which are used in my work. . . .
> Dismembered lock
> Toy frog
> Rubber dragon
> Toy camera
> Assorted wheels and electrical parts
> Clock parts
> Broken comb
> Bent fork
> Various unidentified found objects
> Parts of a radio
> Old RAF bomb sight
> Shaped pieces of wood
> Natural objects such as pieces of bark
> Gramophone parts

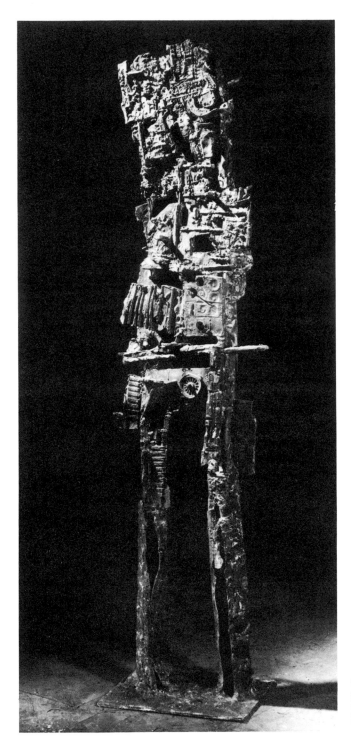

20
Jason 1956, unique bronze,
66½ in. h.
Museum of Modern Art, New
York

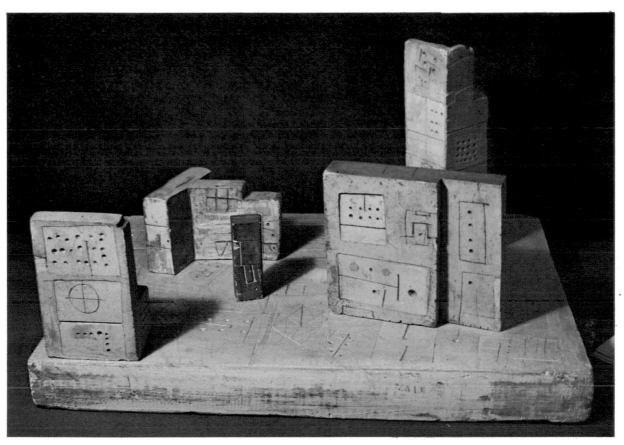

21 Maquette for Unknown Political Prisoner International Sculpture
 Competition, 1952, plaster; base $17 \times 24\frac{1}{16} \times 2\frac{1}{2}$ in., highest piece $11\frac{1}{2}$ in. h.
 Collection Colin St John Wilson, Cambridge

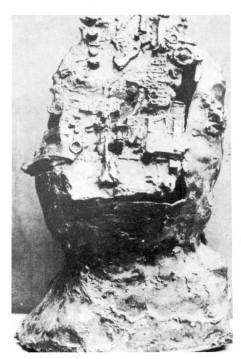 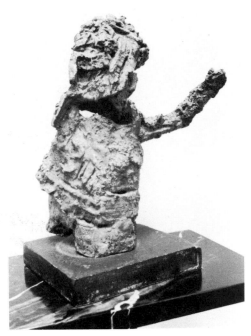

22 *Head* 1957, unique bronze, $38\frac{1}{2}$ in. h. Private collection

23 *Damaged Warrior* 1956, bronze (edition of 6), $9\frac{3}{4} \times 7 \times 7$ in.

> Model automobiles
> Reject die castings from factory tip sites
> CAR WRECKING YARDS AS HUNTING GROUNDS
> (Paolozzi, *Uppercase No. 1*)

This approach owed something to assemblage ideas of the Dadaists and Surrealists. But their works were collections of actual objects. Paolozzi sought greater permanence for his pieces and devised techniques for transforming his collages into bronze. He pointed out that the fundamental method of his found-object style was not new: 'Most of my work is made in wax, then taken to the foundry, either in London or Paris, where artisans cast statues employing a technique only modified since the Egyptians.' (Selz, *New Images of Man*) The particular collage process which he used to make his models for casting into bronze may have owed something to the bronze casts Picasso had made of free-standing sculptural combines in the 1930s and 1940s. But Paolozzi expanded the technique so that numberless items could be collected on one wax sheet.

His process created surfaces whose complexity rivalled those of the medieval and non-European sculptures he admired.

His chosen objects were transformed into the surface of a wax sheet in several ways. Sometimes the artist pressed various objects into clay and removed them leaving a random pattern of their negative impressions. Hot wax was poured over this clay mould to form a finished sheet. Sometimes Paolozzi fastened objects together with intermediary clay areas. A plaster mould could be made of these aggregations, and the wax sheet was then made from the plaster bed (plate 19.) On occasions the artist soldered some of his metal bits together into new structural arrangements before transforming them into a section of one of his sheets. Eventually, from all these methods, the sculptor had 'At the elbow, in wax form: a DIRECTORY OF MASKS, sheets of an ALPHABET OF ELEMENTS awaiting assembly . . . GRAMMAR OF FORMS . . . DICTIONARY OF DESIGN ELEMENTS.' (Paolozzi, *Uppercase No. 1*) The wax sheets could be cut into pieces with a hot knife. The pieces could be heated, bent into new shapes and recombined like the fragments of a collage.

The surfaces of each section exuded layers of meaning connected with the 'sublime of everyday life'. The layers began with the original significance of the found objects which the artist incorporated into the skin of his pieces. Then came the complex processes of mental and formal metamorphosis which were effected by the placement in a collage surface, the transformation into bronze, and the incorporation into a figure or an animal. Each relief area became a fanciful landscape in its own right, an urban cityscape created from the corners of abandoned rubbish heaps.

Paolozzi has a strong feeling for the hidden powers that bestow a potential wonder on all aspects of life. This is combined for him, as for many artists, with an acute awareness of the peculiar super-human aura that often permeates the act of creation. He has spoken of 'THE STUDIO AS . . . DEVILS KITCHEN.' (Paolozzi, *Uppercase No. 1*) He said: 'I've been trying to get away from the idea, in sculpture, of trying to make a Thing — in a way, going beyond the Thing, and trying to make a presence.' (Hamilton, *Contemporary Sculpture*) And he speaks of the 'fantastic, magical or haunting appearance' which is created in his works of this period by the 'variety and accumulation' of found objects on their surfaces. (Roditi, *Dialogues on Art*) 'SYMBOLS CAN BE INTERPRETED IN DIFFERENT WAYS. The WATCH as a calculating machine or jewel, a DOOR as a panel or an art object, the SKULL as a death symbol in the west, or symbol for moon in the east, CAMERA as luxury or necessity. (Paolozzi, *Uppercase No. 1*)

The complete images of Paolozzi's found-object figures had layered meanings of their own. These included elements of the grotesque, of magic, and above all, of the humanized robot and the damaged man.

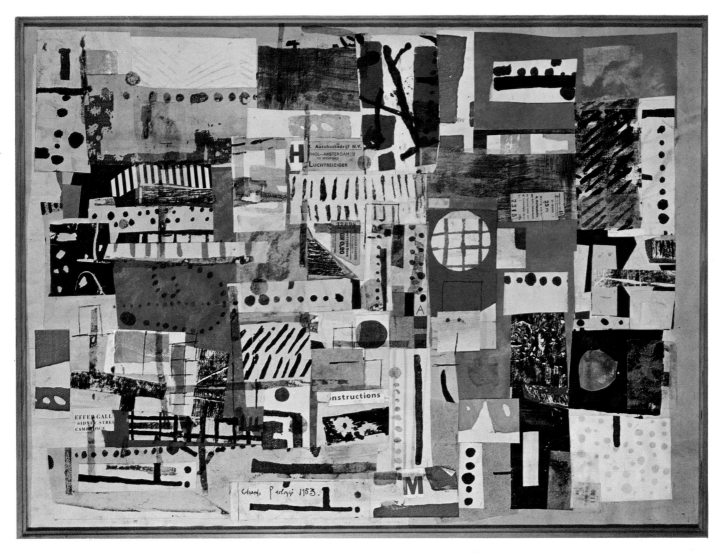

24 *Collage* 1953, coloured paper, silkscreen, ink, water colour, gouache,
 $21\frac{1}{4} \times 28\frac{1}{4}$ in.
 Collection Mrs Gabrielle Keiller, Surrey

Paolozzi constructed colossal heads, standing figures, and fanciful animals in this style. Most of the heads seem like giant three-dimensional versions of *Automobile Head*. The majority are over three feet high. Each head has a different gesture-pose and a different 'facial' expression created by the careful shaping of the skull and the selective positioning of the collaged *objets trouvés* sheets. Seldom were specific facial structures fashioned. Rather, the individual found objects, in the context of their location on the 'face' region, assume the characteristics of anatomical details. Machine topology may evoke city plans, building façades, *and* the human face. Two heads from 1957 illustrate the scope of the artist's particular wax collage technique for expressing this theme. One *Head* (plate 22) was included in a three-man show at Cambridge University in 1959. The other *Head* (plate 25) is in the Harry L. Winston Collection, Birmingham, Michigan, USA. The Cambridge *Head* has a narrow, vertical, cylindrical skull with a cut-away front face-rectangle. The skull is made from a single large wax sheet which has been bent, squeezed, and pummeled into the desired shape. The face-plane is a collage of pieces from the artist's 'dictionary of design elements', which creates an overall impression of hair, forehead, eyes, nose, and enormous upper lip. The partly sunken, askew visage and the deflated aspects of the head and shoulders give the impression of a slightly comic drunk struggling to make a dignified statement with incomplete control of his tongue and lips. The Winston *Head* projects quite a different image. The head is set like a helmet loosely over the shoulders. The upper area of the face is richly cluttered with an array of tiny bits of junk. Below, several long parallel strips unite to suggest simultaneously visor, teeth, moustache and/or beard. The pose of the whole head is more alert, erect, and watchful than that of the Cambridge *Head*, and the Winston piece has little of the humorous overtone which surrounds the Cambridge work.

Sculptures like *Shattered Head,* 1956 (plate 26), and *Damaged Warrior,* 1956 (plate 23), are direct and concentrated expressions of the damaged man. As such, they are related to the sculpted hosts of battered but defiantly alive figures which were created by many European and American artists in the late 1940s and in the 1950s. The brutal grotesqueness of Paolozzi's pieces makes them appropriate symbols for an age in which man cannot escape awareness of death and destruction because mass communication systems instantly relay the gruesome details of horrific catastrophes wrought by man and nature in all parts of the globe. Yet these works are not wholly morbid images. Although they are grotesquely anti-beautiful, they retain a spark of hope-filled life. Their whole compositions work to express this spirit. *Shattered Head,* for example, seems to show the aftermath of a total fragmentation. The head is made of irregular pieces which do not quite fit together. Some gaping fissures seem left by missing slivers that were lost when the shattering

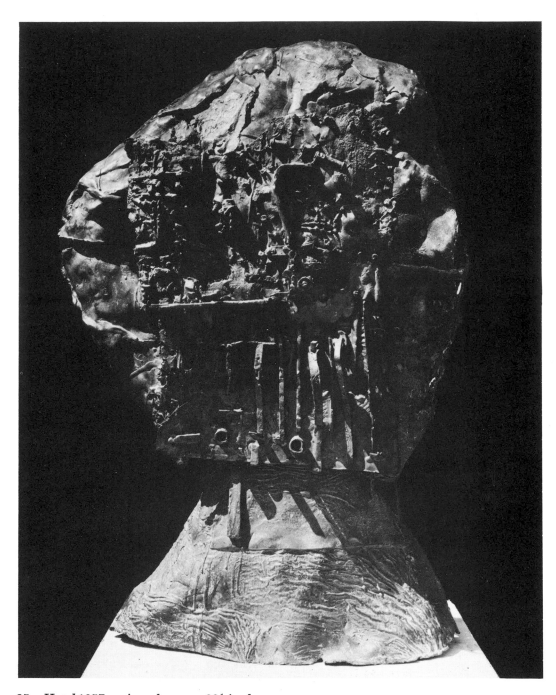

25 *Head* 1957, unique bronze, 38½ in. h.
Harry L. Winston Collection (Dr and Mrs Barnett Malbin),
Birmingham, Michigan, USA

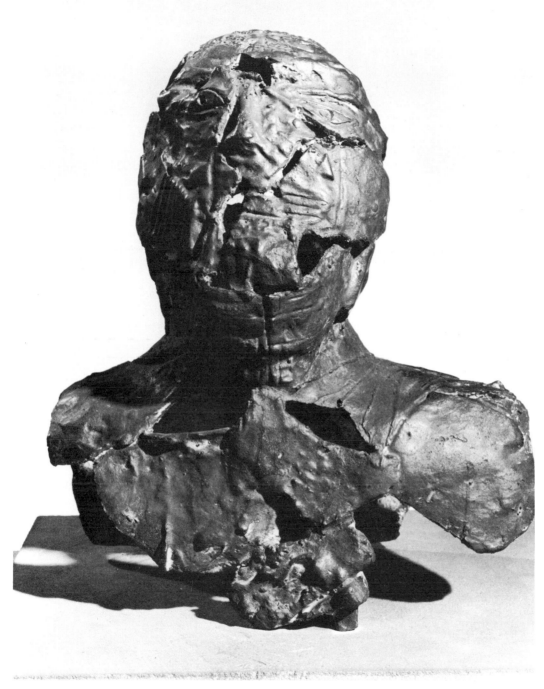

26 *Shattered Head* 1956, bronze (edition of 6), $11\frac{1}{4} \times 9\frac{1}{2} \times 7\frac{1}{4}$ in.

took place. But much of the awkward fit appears to have come through a hasty reassembly which patched the body miraculously together again into the container of a human presence. One senses that the vital spirit might have escaped if more time had been taken in rebuilding the physical shell.

Full standing figures in the found-object style were the culmination of Paolozzi's technical and iconographical ideas in the second half of the 1950s (plates 20, 28). Most of the figures are male. When asked why, the artist replied: 'Maybe it is because of identification. One lives through the sculpture, though one doesn't think that.' (Alloway, *Metallization of a Dream*) Most artists live through their work in one way or another. But many male sculptors concentrate on creating female forms. Why not Paolozzi? Feminine forms suggest mysteries of sex and nature's fruitfulness. Paolozzi is more attracted to the mysteries of a different world:

> Rational order in the technological world can be as fascinating as the fetishes of a Congo witch doctor. . . . SCIENTIFIC PHENO-MENA become SIGNIFICANT IMAGES, the ENGINE FORCE directing the construction of HELLISH MONSTERS
> My occupation can be described as the ERECTION OF HOLLOW GODS with the heads like an eye, the centre part like a retina. This figure can three parts be described as the use of a form of principle of Architectural Anatomy. . . . Metamorphosis of the figure: . . . a CRACKED COLUMN resembling a PETRIFIED TOWER . . . a CRACKED TOWER like a SHATTERED FIGURE, the META-MORPHOSIS OF A COLUMN INTO A FIGURE, INTO A TOWER (Paolozzi, *Uppercase No. 1*)

The feminine form may be brutalized, as Appel and de Kooning have brutalized it, but it lacks the angular shapes which will allow easy transformation into machine parts or into rectangular architecture.

Full standing figures like *Jason*, 1956 (plate 20), combine the images of hollow gods, tower-men, damaged men, and humanized robots. Many of the figures, like *Jason*, have names which refer to the larger-than-life heroes of antiquity. However, the sculptures themselves express not so much the idea of the classical hero as the concept of a modern hero. The greatest heroism in our age is probably that of the common man who survives by no spectacular feats of action but by simply enduring and by maintaining, with fortitude, the semblance of a human existence within the turmoil of daily life. A modern heroic image should not be an ideal figure in the classical sense, removed from and placed above the ordinary world. Thus, *Jason* is the heroic figure transposed to more human scale. His pose is a casually updated classical s-curve. His figure incorporates actual bits of his environment. There are echoes of traditional heroic nudity in the fused machine chunks that compose his head and torso.

But *Jason* is not an ideally beautiful human figure (although his forms do project something of Wölfflin's ideas of baroque beauty). Instead *Jason* is a tower-man. His head, neck, and armless torso are one continuous mass. The effect resembles a swaying, decaying skyscraper. He is also a damaged man, clad in a rather tattered array of found objects. His forms seem inhabited by a somewhat disturbing vital spirit which makes one think of monsters, idols, and gods.

Much of *Jason*'s evocative power may come from its overtones of a mechanized figure — a robot. Paolozzi has had an almost lifelong fascination with robots. Their forms fed his own desire to make personages from manufactured found objects. Iconographically, too, robots have powerful layered meanings, many of which were developed by the science fiction writers whose works Paolozzi devoured in bulk. These fictional robots embodied much of the malaise which affects modern urban man. Robots suffered isolation, estrangement, and oppression in stories because of their 'difference' from true human beings. Robots may be programmed to imitate most human functions, but they cannot experience emotion. The ability to 'feel' is said ultimately to divide the mechanical and 'lower' creatures from the human one. Ironically, it is precisely this ability which is creating major psychological problems as more and more humans find themselves unable to experience strong emotion in the face of the world's massive tragedies. The struggle to *feel* like a human may be further complicated by the present tendency to describe the body as an electronic system and the brain as a computer for processing data. Some men even yearn to escape from human problems by adapting a cool 'mechanical' detachment: 'Machines have less problems. I'd like to be a machine, wouldn't you?' (Andy Warhol) But in fact, such an escape is impossible. The human entity remains notoriously, inefficiently personal. No matter how unfeeling a man tries to be, a note of emotion survives in his core. This may be why one can feel such warm empathy with those robot heroes whose fictional conflicts come from their inexplicable development of an illogical 'heart'. This may also partially explain the potency of Paolozzi's machine-men figures.

In many ways, Paolozzi's standing figures also embody the toughness of the spirit and offer hope that a spark of intelligent awareness (soul?) will endure in the midst of the most destructive forces. *St Sebastian No. 2*, 1957 (plate 28), seems like a victorious survivor of some horrific conflict. The 'body' suggests a hollow, damaged suit of armour — or a homemade robot casing. Inside one senses a living spirit, not threatening, but personable and almost human. Iconographically, St Sebastian was shot full of arrows as punishment for his unpopular religious beliefs. He survived (to be successfully martyred later). His case may somewhat parallel that of today's common man, whose personal beliefs may be the chief expression of his individuality. In a time which seems to fear any deviation from society's established norm, the individual may be

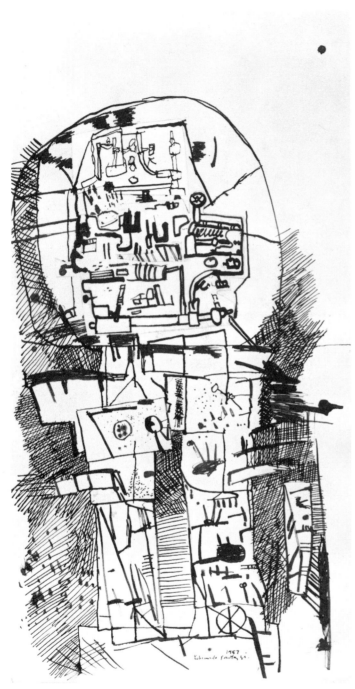

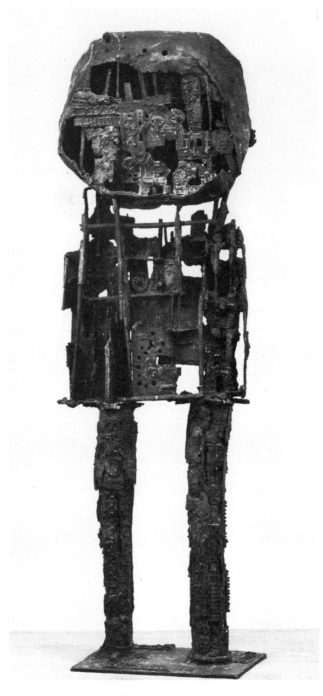

27 *Study for St Sebastian* 1957,
 ink and wash, 20 × 9⅞ in.
 Collection the British Council, London

28 *St Sebastian No. 2* 1957,
 unique bronze, 84¾ in. h.
 The Solomon R. Guggenheim Museum, New York

40

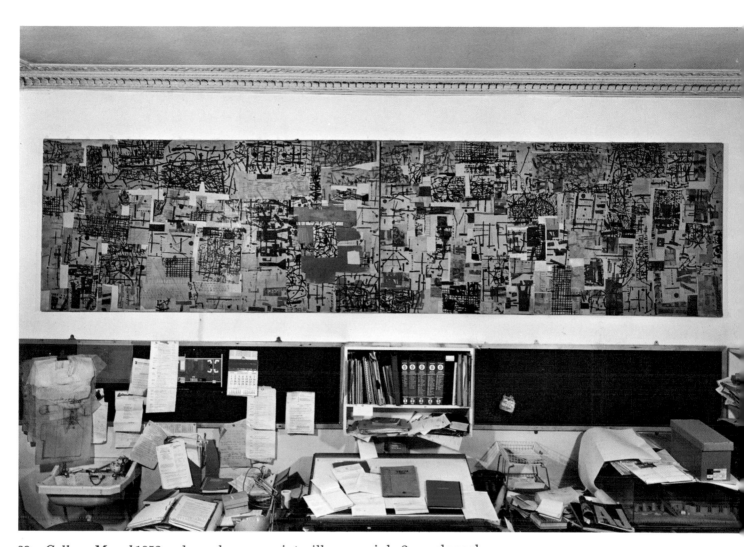

29 *Collage Mural* 1952, coloured paper, paint, silkscreen, ink, 2 panels each
 49 × 97 in., dowelled together
 Collection Fry, Drew and Partners, London

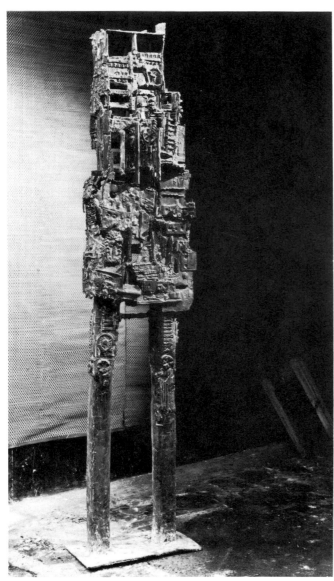

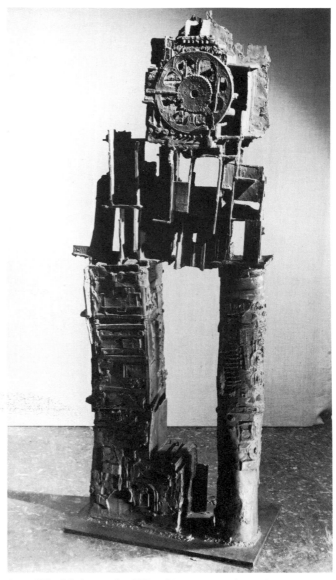

30 *The Philosopher* 1957, unique bronze, 74 in. h.
Collection the British Council, London

31 *His Majesty the Wheel* 1958–9, unique bronze,
60 in. h. Collection Lady Hulton, London

'persecuted' in various ways to try and make his thoughts conform. Paolozzi's image of *St Sebastian No. 2* may indicate that a personal victory in such a situation lies in not being a purely passive recipient. The sculpture has an unyielding stance; on the back are the words 'PLEASE LEAVE ME ALONE'. Together, words and stance suggest not so much a simple plea as a warning. The polite phrasing of the request is social form. But, coupled with the wary posture of the figure itself, it is also the quiet signal of the strong man that his wish for non-violence will be broken if the important activities of his individual world are violated. The head of *St Sebastian No. 2* can be read as an eye with a giant retina. But there is also the sense of the whole world of the human face seen at ultra close range and something of the robot head filled with mysterious machinery. The face of *St Sebastian No. 2* is rather like a lopsided wheel.

Wheels appeared in some of Paolozzi's earliest drawings, and the wheel motif has recurred throughout his career. With the found-object style, he incorporated a variety of actual wheels into his wax sheets, sometimes, as in *His Majesty the Wheel*, 1958–9 (plate 31), using one large wheel for the whole face. In the title of *His Majesty the Wheel*, even the word-symbol 'wheel' becomes important:

> Paolozzi . . . points out that the words 'His Majesty' are what he calls a 'fairy tale idea'. In addition, the wheel is 'a quickly read symbol of the man-made object' and by extension connectable with 'clocks and precision engineering'. He adds that the title was taken from a *Time* magazine story concerning Jimmy Hoffa, the US trade-union leader, so that the idea of modern political corruption and current slang ('wheel' as a big man) were also present. . . . There is . . . also, the wheel as a cultural symbol (its invention was second only to the discovery of fire in prehistory).
> (Alloway, *Metallization of a Dream*)

This title probably had the most complex conscious layerings of meaning of any of Paolozzi's works of the 1950s. Such word play indicated the artist's growing fascination with word games, which grew to inspire his writings of the 1960s.

The face of *His Majesty the Wheel* is a mechanical, rather than a vehicular, wheel. It covers a frontal opening in an angular, box-like skull. This signals the slight shift of expression which takes place in Paolozzi's machine-men in the late 1950s. The 'Architectural Anatomy' is stressed until the sculptures resemble stationary mechanical entities. The figure has four definite sides, rather than the two major sides favoured by the artist in most earlier designs. One leg is a cylinder; the other is a huge square leaning tower with a blocky foot turned sideways at the lower end. The torso is a series of rickety shuttered boxes which allows space to penetrate the central mass of the figure in a partially

regulated way. The effect is somewhere between that of a fantasy doll's house and the remains of an apartment building which has been partly disintegrated by wreckers or bombs. One thinks again of Paolozzi's phrases: 'torso like a tornado struck town, a hillside or the slums of Calcutta' (Paolozzi, *Uppercase No. 1*) In *The Philosopher,* 1957 (plate 30), the transformation of figure into rude architecture is so complete that there remains little of the figure about it.

The animals Paolozzi made in his found-object techniques suggest both natural creatures and fantastic mechanized pets. *Chinese Dog II*, 1958 (plate 32), has a massive head and a long thin body with four column-legs. The intricate, somewhat decorative effect of its found-object surfaces has an oriental look which recalls surface designs on some Chinese sculpture, pottery, and metal work. And the peculiarly awkward, yet defiant and alert, stance of the dog also evokes the Pekinese canine breed. Paolozzi created equally mythical 'frogs' with the found-object style too. *Large Frog* (*New Version*), 1958 (plate 33), has a face like a machine switchboard. Its body is a flattened sphere suspended on four crude funnel legs. The skin of its back is a mechanical landscape in which individual objects are identifiable, but in which the original wax casts have been partially brutalized, fragmented, or melted to ensure their formal union with the surrounding surface. The frog and the dog both have that quality of sensate being which Paolozzi infuses into most of his works. With this blend of biological and mechanical forms, these creatures become animal-ikons, suitable companions to 'hollow gods' like *St Sebastian No. 2* or *His Majesty the Wheel*.

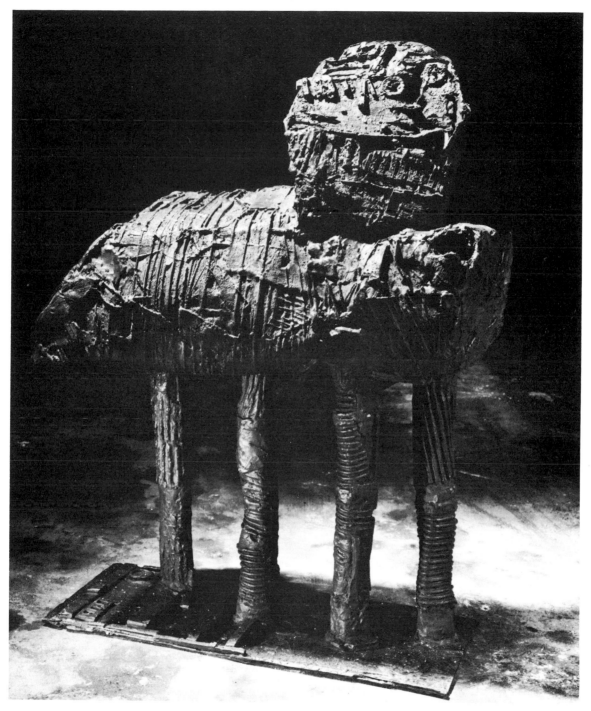

32 *Chinese Dog II* 1958, bronze (edition of 6), 36 × 25 × 11 in.

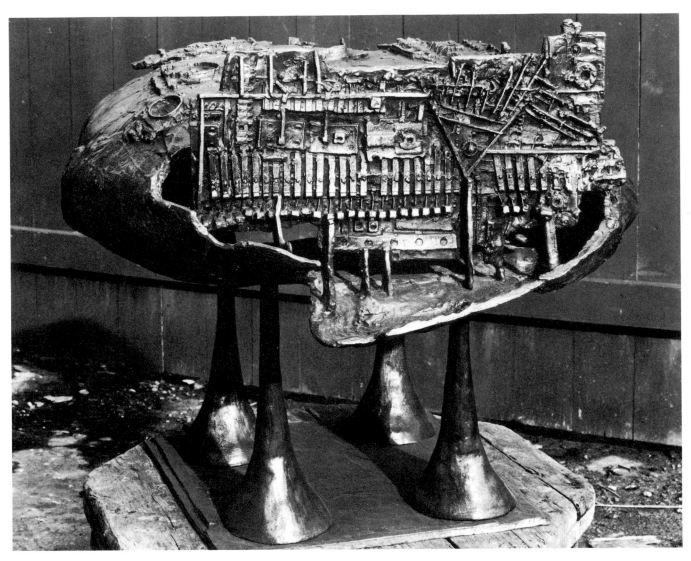

33 *Large Frog* (*New Version*) 1958, bronze, (edition of 6), 28 × 32 × 32 in.

The sculpture of the 1960s

Toward the end of the 1950s Paolozzi was moving toward a new vision, one which expressed his growing absorption with the processes and products of modern technology. Gradually he reinvented his approach to sculpture by developing a machine-style which combined his unique sense of the sculptural presence with a contemporary machine aesthetic. In the early 1960s his tower-figures moved away from two-legged parallels with human anatomy and became four-sided block-tower presences which blended the imagery of modern architecture with that of the industrial machine. The forms of transitional works like *Tyrannical Tower*, 1961 (plate 35), resemble actual machine parts, but they were hand-fabrications based on industrial designs and made in the ancient wax-to-bronze technique. The next step was to develop a way of using mass-production methods to create 'idols' for the technological age.

The development of the new style began in the early 1960s when Paolozzi entered into a special artist-industry relationship with two firms. One company, W. L. Shepherd of London, makes industrial patterns and operates a non-ferrous foundry. The other firm, C. W. Juby Ltd in Ipswich, is a precision engineering works. The artist searched for suitable ready-made machine parts which he could order from various commercial engineering supply houses and catalogues. He also made drawings or wax models of original designs. And while teaching in Germany he began to make some engineering templates in plywood. The process of designing original units usually began with drawings, which might be gesture drawings (plate 38) or relatively exact composition studies. Professionals prepared blue-prints from his drawings and models. Patterns were prepared for sand-casting. The specified number of each unit was then produced at the foundry. The machined forms have a regularity and precision of surface which would have been impossible to achieve with Paolozzi's older methods. The manufactured units became the 'words' in the vocabulary of his new machine-style. The completed units and the ordered standard parts were taken to the Ipswich factory, where the artist later supervised the assembly of his sculptures. The pieces were bolted and welded together. Paolozzi and the welder created many deliberately rough joins which contrasted the effect of a hand-operated tool with the clean precision of mass-produced forms. The artist and his welder also sometimes deliberately used distortions of form caused by the heat of the welding process to further 'humanize' the machine presences.

At first the process of assembly was quite a rigid one. In 1962 Paolozzi was still spending much time in Germany, and had not found a trained

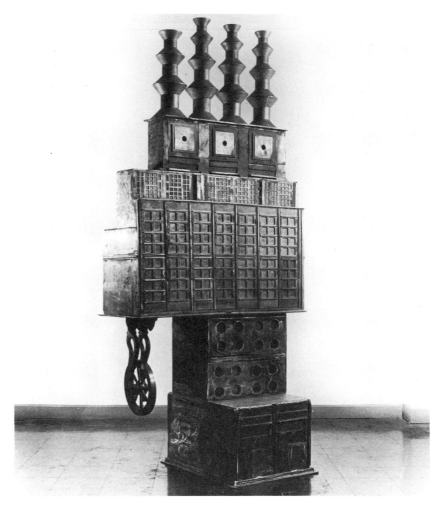

34 *Markoni Capital* 1962, gunmetal and brass, 89¼ × 38¾ × 26½ in.
Collection the artist

technician in England with whom he could creatively collaborate at long
distance. He prepared careful sketches and precise drawings of desired
compositions (plate 43). These were sent to the factory where the selected
units were tack welded into the indicated positions. When Paolozzi
visited the factory, he could have changes made. The final composition
was then fixed by both bolts and welded seams. By 1963 Paolozzi was
back in England, and he was working with a technician who could
prefabricate elements without consulting precise drawings. This shift

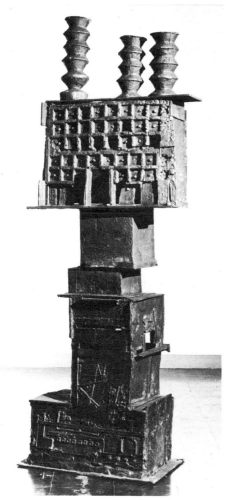

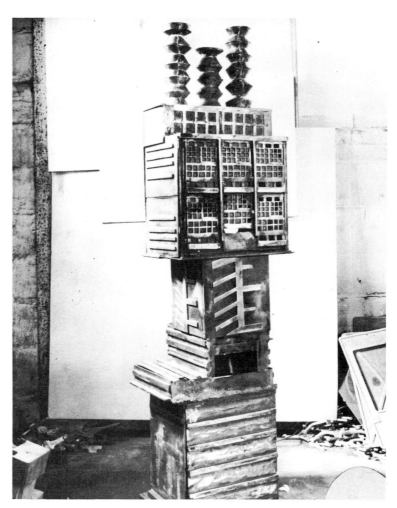

35 *Tyrannical Tower* 1961, unique bronze, 72 × 22¾ × 15 in. Collection Mrs Gabrielle Keiller, Surrey

36 *Town Tower* 1962, gunmetal, brass and bronze, 77½ × 17 × 22 in. Collection the artist

in procedure allowed a greater spontaneity and freedom in the making of the sculpture which led rapidly to a new compositional freedom as well. In 1962 Paolozzi often combined more than one metal in one piece. A great deal of technical skill was required to weld these diverse materials. In 1963 Paolozzi began having his elements cast in a special non-corrosive aluminium, used in the aircraft industry. The welding process became simpler, and this may also have helped in the development of a freer approach to the final assembling.

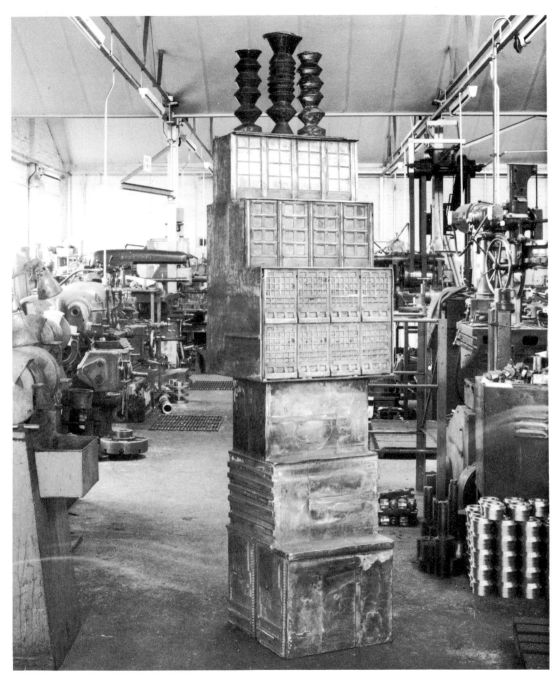

37 *Konsul* 1962, gunmental and brass, $92 \times 23\frac{1}{2} \times 25$ in.
Collection the artist

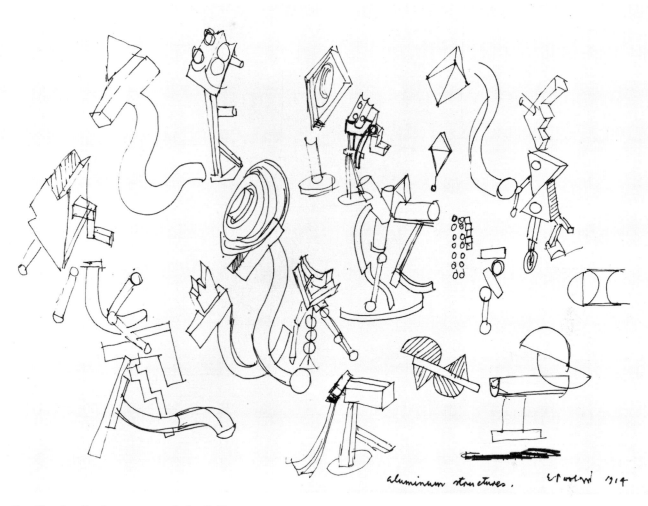

aluminum structures. Paolozzi 1964

38 *Studies for Sculpture* 1964, ink. Collection the artist

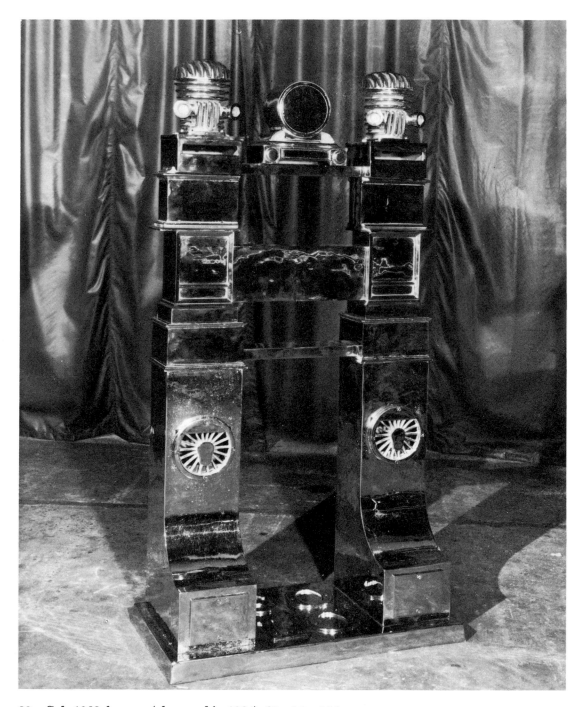

39 *Solo* 1962, bronze (chromed in 1964), 62 × 16 × 32 in.
Collection Paul McCartney, London

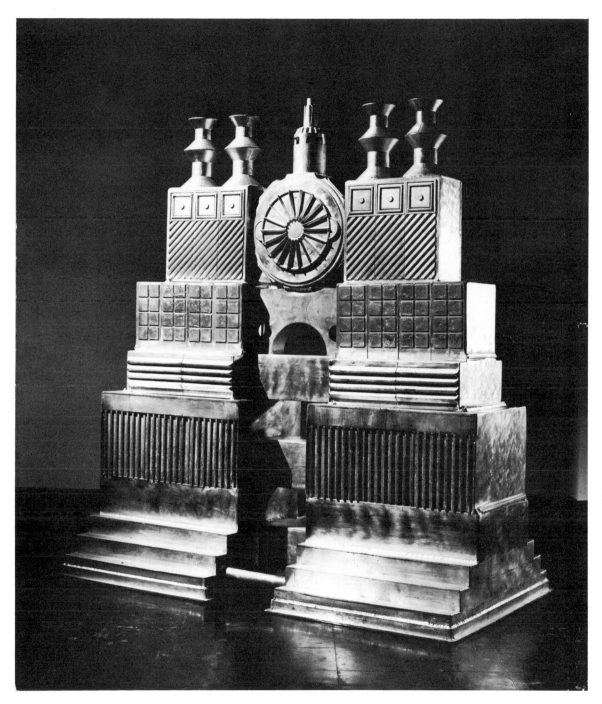

40 *Twin Towers of the Sfinx State II* 1962, aluminium, $67\frac{1}{2} \times 61\frac{1}{4} \times 32\frac{1}{4}$ in.
Collection the artist

Paolozzi saw this assembly process as a kind of industrial collage:

> The ship, the aeroplane, the motorcar are all made from component parts really. They all have to be constructed, and one uses this same means. But there is also the other idea in collage . . . a very direct way of working — cutting out sheets of coloured paper, for example. One is able to manipulate, to move, and use certain laws which are in a way blocked off if you try to do a pencil drawing, say, and then fill in the coloured areas. It's the same too if you use a direct analogy. If you want to make a metal box in sculpture, there is a traditional way. You can supply a plaster block to the foundry, and going through the lost-wax technique you will eventually get it back in bronze. But there is another approach in sheer engineering terms: you cut an aluminium sheet into six parts and weld them together, and you have the metal box. . . . The emphasis really is on the idea of directness the way I see collage.
> (Hamilton, *Contemporary Sculpture*)

From a series of elements in wood, $\frac{\text{of recording}}{\text{of recorded}}$
dimensions translated into metal, these pieces
duplicated and multiplied become
component parts.
Multi-useful fort like presences, silhouettes of
strength, edges hard and sharp
Assembly decided on the floor of the workshop. . . .

Spread in the concrete floor
of the pattern shop these
index items are arranged
for assembly. Filet plates
& gunmetal T-bars
aluminium ladders
Tracing paper designed
sand made machine polished
positive & negative
moulded bases placed
The clock case supported
Edges sharp to the touch
endlessley modified
bolted sections
screwed on numbers (Paolozzi, *Metafisikal Translations*)

This industrial collage process gave Paolozzi the direct, spontaneous control over the finished piece which he found essential to the creation

54

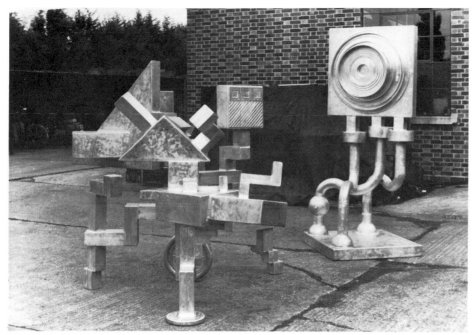

41 Left: *Karakas* 1964, aluminium (repainted in 1966), 41 × 84½ × 48 in.;
collection the artist. Right: Lotus 1964, aluminium, 90 × 36 × 36 in.;
private collection

of the image. *Town Tower*, 1962 (plate 36), was an early experiment with
the new vocabulary. Essentially, it is a translation of the transitional
Tyrannical Tower into the new technique. With works like *Konsul*, 1962
(plate 37), Paolozzi creates mature machine style tower-figures which
also evoke images of fanciful mechanisms related to fantastic console
machines, computers, commercial espresso makers, or hallucinatory slot
machines.

In the construction of his machine-style works, Paolozzi acts as head
ideas-man and contractor. This parallels the move by many other con-
temporary artists from hand-made pieces to works based on a new
industrial aesthetic. More and more creators have relinquished hand

55

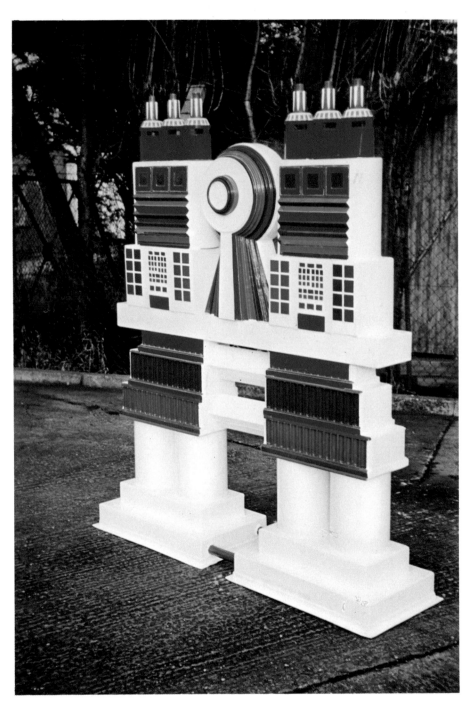

42 *Tower for Mondrian* 1963–4, aluminium (painted in 1966), $70 \times 61\frac{1}{2} \times 17\frac{1}{2}$ in.
Collection the artist

control of their works to explore the creative possibilities of mass-production techniques and materials. Industrial production cannot be accomplished by the isolated individual working on his own. The artist becomes the generating catalyst for the action of a team of technically trained men. The designer-artist considers the germinating idea the essential core of his work of art. He retains mind control over the artistic process by using his team of human technical workers as living tools. The technicians execute the works with varying degrees of independence according to how much the artist regards them as living tools and how much as rubber stamps. For Paolozzi, a complete mechanical reproduction of a fixed idea would be far too sterile a method of making a work of art. He arms himself as fully as possible with technical knowledge about the method of production he has chosen for a given work. He thinks out ideas in the form of free drawings and prepares 'final' preliminary ideas, often in sketches or models (plate 38). Then he works with the professionals to create the work of art. Always he is open to suggestions about new ideas of technical modifications which might help most effectively to realize his conception. Always the process must retain the precious element of spontaneity in the assembly of the works.

In 1962 Paolozzi created a series of twin-tower images which were essentially the design of *Konsul* simplified and then doubled. The earliest group with the twin-tower design was the *Mars* series, named for the first work with that composition. The group included six sculptures, three in aluminium and three in bronze. One, *Solo* (plate 39), was later chrome-plated. Except for *Solo*, the complete series has since been scrapped or 'cannibalized' for units to include in later works. All six pieces were variations on the same theme and incorporated many of the same formal units. But each had a different arrangement of these elements; each used the same formal vocabulary to make separate 'sentences', 'phrases', and 'statements'.

In the twin-tower series, Paolozzi deliberately provided many potential interpretative levels for the viewer. The basic post and lintel design was reminiscent of the monumental gateway, one image which fascinated the artist at this time. In his book *Metafisikal Translations* (1962), Paolozzi wrote that the machine-style works were part of the 'search for arch-types to aid the Metallization of the "Dream".' The deliberate pun is related to another area of Paolozzi's interests. In the early 1960s he became extremely language conscious. Part of his obsession with 'language games' may have been stimulated by his dual linguistic life in German and English. The title of the first sculpture in the series, *Mars*, for example, partakes of a linguistic gamesmanship — the name is that both of a planet and of a Roman god. Mars was the god of war, war is modern big business, and on one page of *Metafisikal Translations* Paolozzi put the slogan-title MARS CONSOLIDATED, while another page bore the legend 'Toy as War GOD, GOD as toy'. The image of an

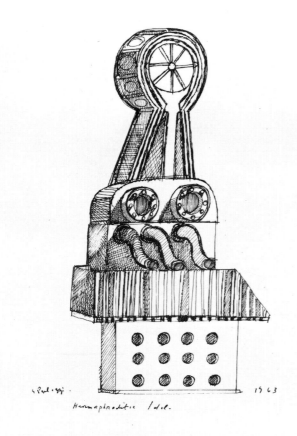

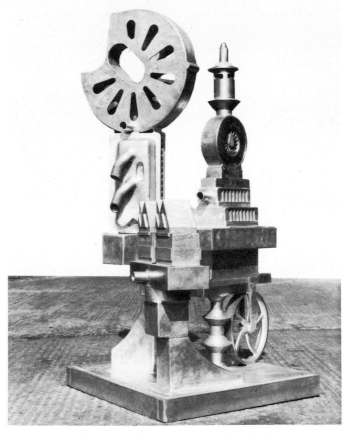

43 *Hermaphroditic Idol* 1963, ink, $12\frac{5}{8} \times 9\frac{1}{2}$ in. Collection the artist

44 *Towards a New Laocoon* 1963, aluminium, $96 \times 50 \times 36$ in. Collection the artist

implacable, impregnable military machine was projected especially strongly by the pieces like *Solo* with twin robot heads.

The machine-style works illustrate Paolozzi's increasing use of geometrical forms in his works of the 1960s. Echoes of geometry had occurred in some of his earlier works, like the Paris Fair Booth drawings. But in the 1960s, geometrical shapes appear with the new precision of the machine-style. In twin-tower images like *Twin Towers of the Sfinx State II*, 1962 (plate 40) and *Tower for Mondrian*, 1963–4 (plate 42), cylinders and rows of squares reinforce the rigid symmetry and the ponderous, almost regal order of the designs, creating metaphors for computerized corporation directors or robot heads of state. As Paolozzi's

machine-style works became freer in design, his use of geometry became correspondingly easier, more varied, and less complex. *Lotus*, 1964 (plate 41), for example, poises a single large square slab (filled with a relief of concentric circles) on three sinuous tubular legs. Always Paolozzi uses geometry in a particularly personal way. He makes intuitive combinations of geometric shapes into structures which have little to do with logical mathematical laws. As is the case with all of Paolozzi's source material, geometric images are passed through the filter of his mind and become subsumed into the creative matrix which forms his personal vision. He has spoken of his 'desire to try and find some kind of clues outside of the orthodox art channels, including outside modern art, outside contemporary zones, some kind of means of constructing something without necessarily resorting to programmatic art — to try and use geometry toward an original art, a personal angle.' (Hamilton, *Contemporary Sculpture*) He even speculated about the possibilities of using colours to multiply geometrical references in his sculptures: 'Certain geometrical ingredients such as variations on the square or the curve, the stripe, the circle, would be applied by the transfer process to the geometric solids of the sculpture, so you have geometry on two levels.' (Hamilton, *Contemporary Sculpture*) Many contemporary artists, from Max Bill to Tony Smith, have based their sculptural structures on universal mathematical laws. But the role of maths in their works is very different from Paolozzi's highly personal use of geometry to create the units for his machine-style presences.

The almost total symmetry of the single and the double tower pieces prohibits these works from having much sense of gesture, and their remote bearings preclude humour. Especially in the twin-tower pieces, the total effect is formal, imperious, and related to the requirement which forces monarchs to refer to themselves as 'we'. However, in 1962–3 Paolozzi also created some single figures which exude a more witty, personalized presence. *Diana as an Engine I*, 1963, painted in 1966 (plate 45), is a machine-age goddess with a 'keyhole-shaped' head-and-torso. Upright motor segments march stiffly around the circumference of the head like locks of robot hair. Twin ring-breasts adorn the body both at the front and the back. There are two slightly different 'faces' made of concentric rings; otherwise the two main sides are identical. The figure was originally raised on a single open metal table, since destroyed. Of *Diana as an Engine I*, Paolozzi said:

> I was trying to make a specific image which depended partly on the real radial engine and partly on a certain casting designed by me — it has a form of edging which was slightly suggestive of an idea. Early forms of society worshipped an image of a symbol which represented some dominant force, and I see something related to this today when one does a precise or specific image which represents

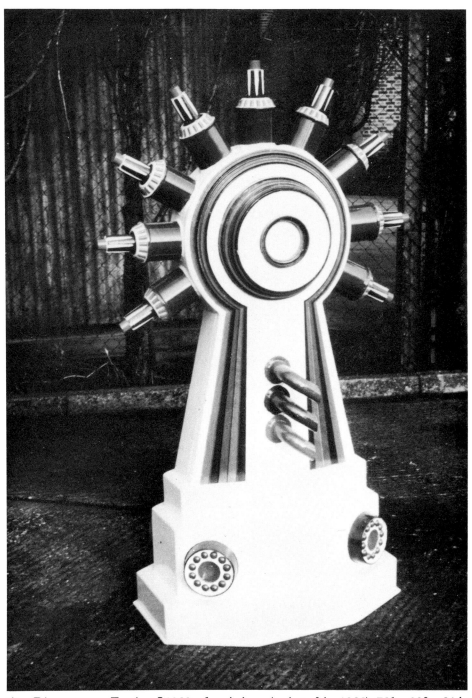

45 *Diana as an Engine I* 1963, aluminium (painted in 1966), $76\frac{1}{4} \times 38\frac{3}{8} \times 21$ in.
Collection the artist

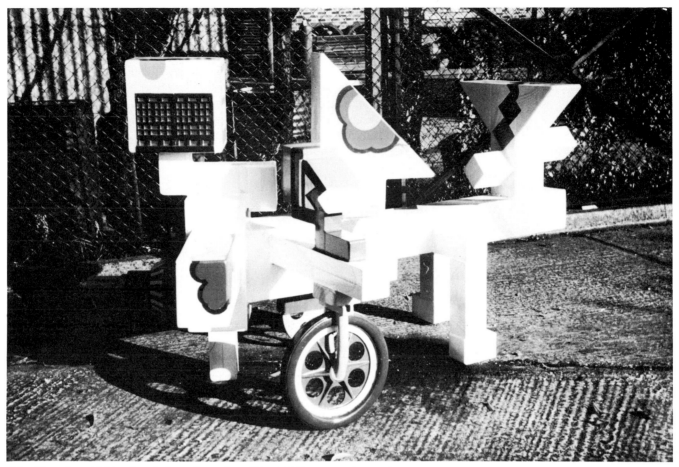

46 *Karakas* 1964, aluminium (repainted in 1966), 41 × 84½ × 48 in.
 Collection the artist

in a small way the kind of man-made forces which contribute to certain man-made articles I am involved with.
(Hamilton, *Contemporary Sculpture*)

Shortly after the completion of *Diana as an Engine I*, Paolozzi began to move further away from the symmetry which characterized many of his works in 1962–3. *Towards a New Laocoon*, 1963 (plate 44), and *Mekanik's Bench*, 1963 (plate 49), represent two intermediate steps toward greater compositional freedom. Each piece has a group of machine-style figures placed in a rather self-consciously casual arrangement on a stage-base. However, the actual presences created in the two sculptures represent very different subjects. *Towards a New Laocoon* is a modern mechanical metaphor for the Hellenistic *Laocoön* sculpture group, while *Mekanik's Bench* embodies the hermetic quality of a modern cluttered workshop bench. Paolozzi found part of his idea for *Mekanik's Bench* in a series of old-fashioned drawings of mechnical still-lifes. (Several are reproduced in *Metafisikal Translations*.) He saw a parallel between the mysterious evocative power of the drawn piles of machine parts and the stack of his own manufactured units in the shop waiting to be transformed into finished machine-style works (plate 48):

> Combination of furniture and machine Hybrid
> combination on a table.
> . . . A cycle of changing references gathered together
> A collection of human artifacts
> Switch gear
> Human hand factors assembled, edited, rearranged
> New analogies cross referenced and cross detailed . . .
> MEKANIKS BENCH
> (Paolozzi, *Metafisikal Translations*)

> I am using anonymity in the same sense that the actual raw materials, when they arrive and lie around on the floor of the workshop, are things that nobody would give a second glance. . . . Part of the battle now is to try and resolve these anonymous materials into . . . a poetic idea . . . such as the mechanic's bench . . . or the aeroplane.
> (Hamilton, *Contemporary Sculpture*)

The design of *Karakas*, 1964, repainted in 1966 (plate 46) is faintly reminiscent of an hallucinatory flying machine. The composition spreads out horizontally in several directions, but one main horizontal beam suggests a fuselage, and cross beams loosely evoke wings while two unmatched wheels and two block 'feet' suggest a long plane propped up in a hangar. Fantasy tail and superstructure images are projected by the collection

62

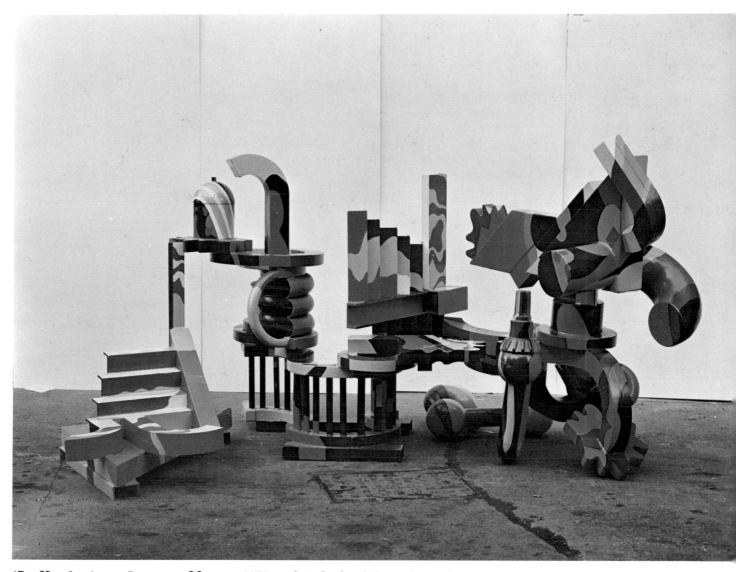

47 *Hamlet in a Japanese Manner* 1966, painted aluminium, 3 sections;
A 65 × 68 × 42 in., B 60¾ × 85½ × 52¼ in., C 43 × 35⅛ × 43 in.
Collection the artist

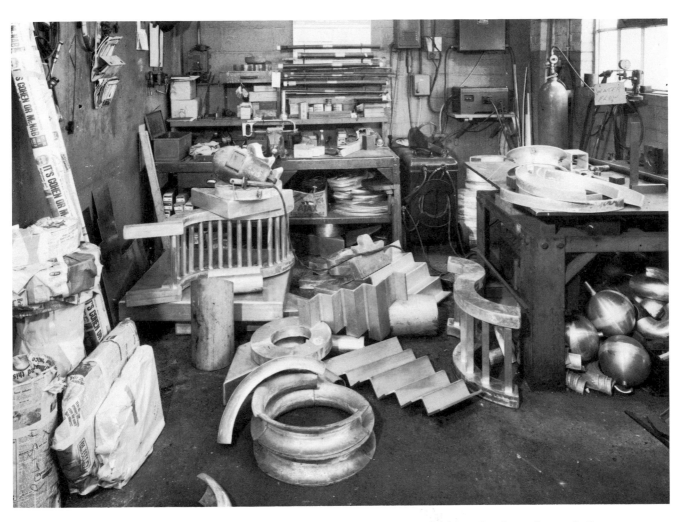

48 Units for machine-style pieces in workshop

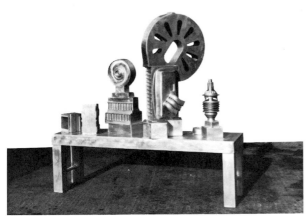

49 *Mekanik's Bench* 1963, aluminium, 71 × 62 × 22 in.
Pace Gallery, New York

of forms which rise from the main horizontal frame. The sense of machine presence is less cohesive, less definite than in earlier machine-style pieces. Formally, *Karakas* departs from earlier designs also, by eliminating the base plate on which most earlier works had stood. This gives the piece a more open and visually active appearance. The elements are, for the most part, three-dimensional variations of simple geometric forms. Paolozzi's sculptures of 1962 and 1963 each had three or four vantage points from which they could be most effectively seen. Beginning with *Karakas*, the viewer is tempted to explore a number of viewing angles around the piece. The forms entice the viewer to move around the work, and the sculpture presents an almost continuous chain of interesting images as one circles it.

The combination in *Karakas* of blocky triangular and rectangular slabs and beams with their brushed aluminium surfaces may have been partly inspired by some of the works of David Smith in the late 1950s and early 1960s. In many works, Smith worked with sheet steel and used a welding torch to cut and fabricate three-dimensional cubic shapes. Many of his works in the *Cubi* series of early 1963 resemble *Karakas* in their compositions of blocky masses into designs in which each unit retains absolute shape identity at the same time that the identity is sharpened and amplified by its position in the group. As in *Karakas*, space flows through Smith's works and around the individual block units. However, compositionally, most of Smith's works in this style are closer in some ways to other Paolozzi sculptures than to *Karakas*. For Smith usually designed vertical pieces which had two major viewing sides. These works usually stood on slab bases. *Karakas*, on the contrary, is a horizontal composition which stands on no base and which has almost an infinite number of viewpoints.

The formal qualities of *Karakas* also seem to link it with some of the compositional ideas Anthony Caro was exploring in the early 1960s. Caro eschewed bases for his sculptures, setting the pieces directly on the ground or on the floor. In most works of these years, Caro assembled 'found' pieces of steel beams and steel girders (cut to the desired lengths by the artist) into open horizontal compositions. Like Smith's pieces and the majority of Paolozzi's pre-*Karakas* machine-style works, much of Caro's sculpture of this period was designed with two major viewing sides. Certain elements cross the main planes. The heavy steel units are transformed into the lines and planes of a space drawing in which the clear silhouettes of the forms reinforce their compositional meaning as vectors of movement in space. No two shapes or directions are the same. Large c- and i- and l-beams incline at improbable angles or float on almost invisible welded connections. Caro's horizontal compositions of this period emphasize line, plane, and an almost anti-natural lightness. They do not have the sense of formal masses occupying space which the elements of Paolozzi's *Karakas* have. And the 'image' of all Paolozzi's

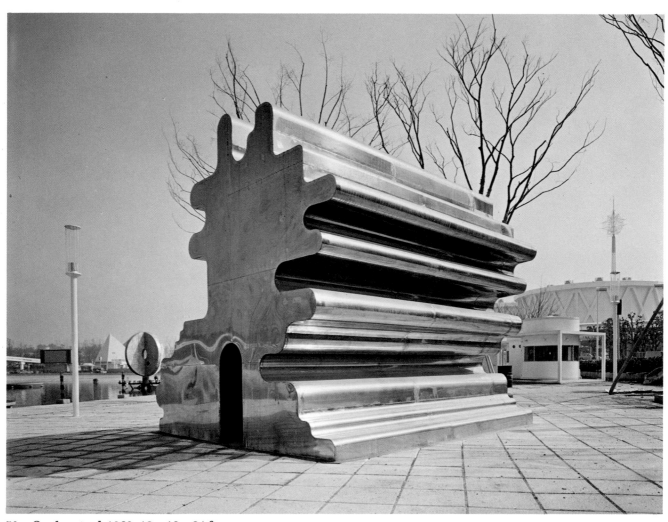

50 Osaka steel 1969, 12 × 12 × 24 ft
Commissioned for Expo 70, Osaka, Japan

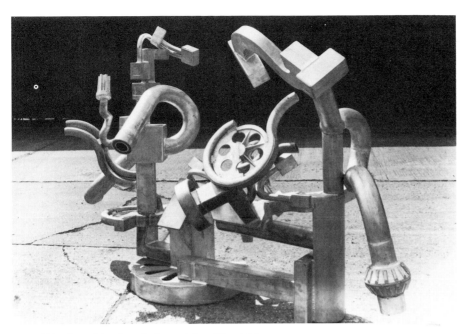

51 *Crash* 1964, aluminium, 96 × 59 × 36 in.
Ulster Museum, Belfast, Northern Ireland

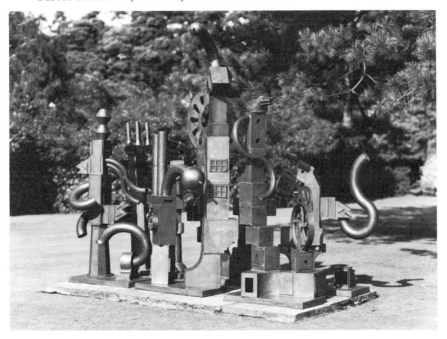

52 *Rio* 1964–5, bronze, largest piece 8 ft h.
Collection Mrs Gabrielle Keiller, Surrey

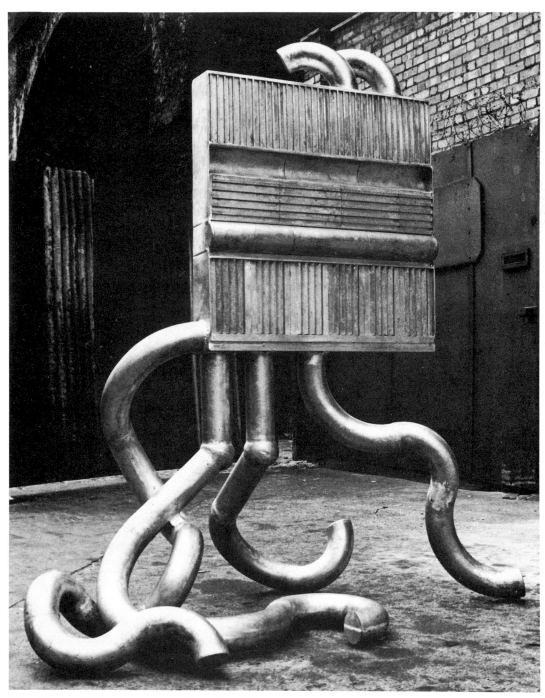

53 *Medea* 1964, aluminium, 81 × 72 × 45 in.
Rijksmuseum Kröller-Müller, Otterlo

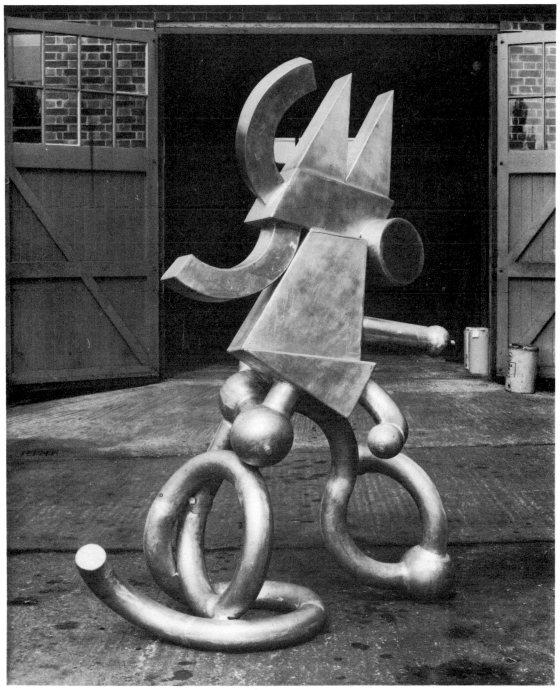

54 *Parrot* 1964, aluminium, 83 × 60 × 33 in.
Collection Mr and Mrs Albert List, New York

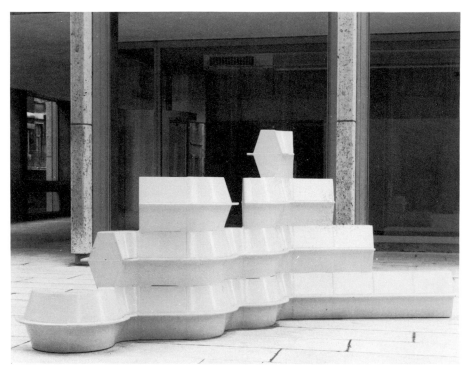

55 *Pan Am* 1966, painted aluminium, $56\frac{1}{2} \times 31 \times 37$ in.
Collection the artist

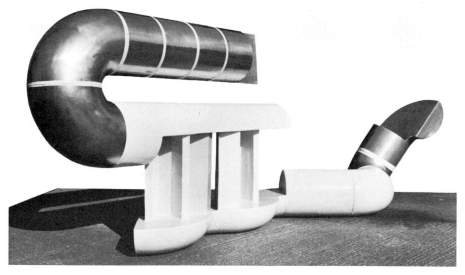

56 *Ovemk* 1966–7, painted and polished aluminium, $56\frac{1}{2} \times 31 \times 37$ in.
Collection the artist

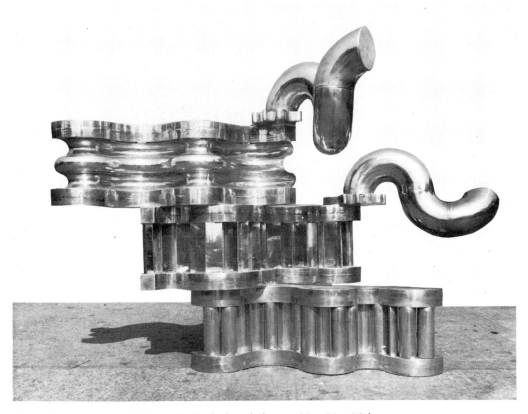

57 *Akapotik Rose* 1965, polished aluminium, 109 × 73 × 50 in.
Private collection

works is significantly different from that of either Caro's or Smith's
pieces. For both Smith and Caro used pure abstract shapes which retain
their abstract identity in the finished works, however often imaginative
viewers may read Smith's upright compositions as figures or draw
parallels between Caro's works and the structures of playground equip-
ment or similar fantastic constructions. Whenever Paolozzi combines
geometric forms, he is 'trying to get away from the idea, in sculpture, of
trying to make a Thing — in a way, going beyond the Thing, and trying
to make a presence.' (Hamilton, *Contemporary Sculpture*)

Karakas was one of the first sculptures Paolozzi painted. It was one of
several works he covered with single pastel shades in 1964. Possibly
some of the painted sculptures which David Smith and Anthony Caro
were producing at this time helped to inspire Paolozzi to experiment
with the effects of colour in his own work. In any case, the monochrome

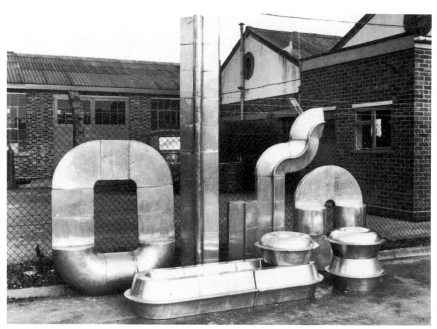

58 *Domino* 1967–8, polished metal, 9 pieces, tallest/longest 'beam' $122 \times 15\frac{7}{8} \times 17\frac{1}{2}$ in. Collection the artist

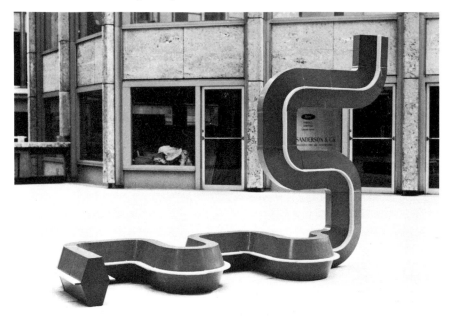

59 *Es Es* 1966, painted aluminium, $87\frac{1}{2} \times 130\frac{1}{2} \times 37\frac{1}{4}$ in. Collection the artist

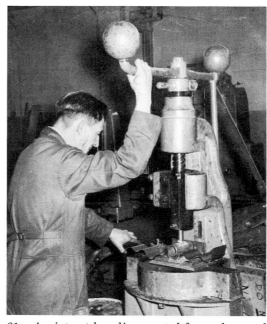

60 Paolozzi cutting metal for a chromed-steel piece

61 Assistant bending metal for a chromed-steel piece

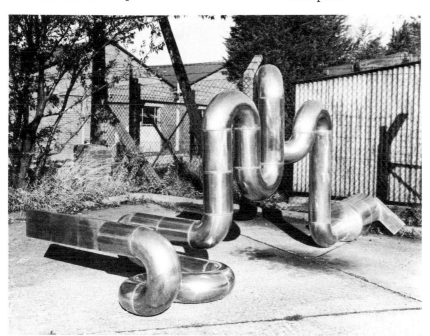

62 *Gexhi* 1967, polished alloy, $71\frac{1}{2} \times 147\frac{1}{2} \times 67\frac{1}{4}$ in.
Collection the artist

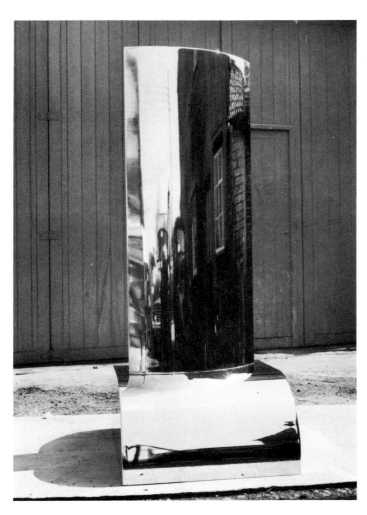

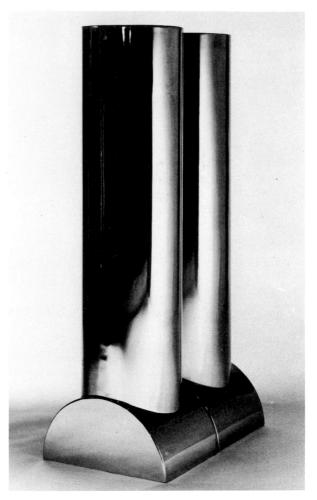

63 *Daola* 1967, chromed steel, $62 \times 34\frac{1}{4} \times 24\frac{1}{4}$ in.
Pace Gallery, New York

64 *Amir-Amur* 1967, 2 versions, 1 in chromed steel
and 1 in stainless steel, each column
$71\frac{5}{8} \times 21 \times 14\frac{1}{8}$ in. Pace Gallery, New York

coats Paolozzi first gave to works like *Karakas* created a certain unity
in the pieces and helped to enhance perception of their complex internal
formal relationships. By late 1964 the artist was experimenting with
multi-colour designs. He painted or repainted many of the earlier
machine-style sculptures like *Diana as an Engine I* in patterns which

clarified their designs and increased their sense of 'membership' in the world of gleaming and fanciful mechanisms.

The problem of colour in sculpture has been a thorny one through the centuries. The controversy concerns whether or not the application of colour lessens the perception of mass, weight, and volume — the traditional characteristics of the sculptural art. In past ages, colour was most often used to imitate the world of nature. One might say that no diminished awareness of mass takes place when one encounters familiar colour patterns. Even so, such colour may lessen the perception of volume more than colour used in a non-natural manner, for few people have a well-developed stereognostic sense of the real world. Naturalistic colour might encourage viewers to revert to ordinary imprecise patterns of perception. On the other hand, a figurative work which exposes its component materials might force the viewer into 'seeing' the three-dimensional shapes before his eyes, for the naked material would be more materially present to his perception than illusionistically coloured marble skin or painted drapery. Colour applied to non-objective forms may either reinforce the perception of mass and three-dimensional form or nullify it. In the twentieth century, there has been a narrowing gap between painting and sculpture. Sculptors have seemed to use colour as often to stress surface and deny weight as to reinforce a sense of mass and volume. Paolozzi has used colour in both ways. The single colour coats or the clear patterns of works like *Diana as an Engine I* strengthen the perception of their three dimensional forms.

In 1966 Paolozzi repainted *Karakas* in a new experimental 'camouflage' style which he then applied to several other works. This style, in many ways, optically challenged the solidity of the sculptural elements. The principle of camouflage is to conceal objects. Paolozzi's bright non-earth colours prevent a complete visual dissolution of tangible forms. However, the colour areas distort the clean machine shapes and create new, sometimes confusing, forms within forms. The visual ambiguity may lead the viewer to ponder the nature and reality of·all material shapes. The rich patterns may also recall Paolozzi's poetic musings in 1958: '. . . the printed circuit, intricate, complex, evocative, as pretty as a Fabergé jewel.' (*Uppercase No. 1*)

Crash, 1964 (plate 51), carries the new compositional freedom of *Karakas* further. It is a machine-style metaphor for an action-packed event. The image of the crash had fascinated Paolozzi for many years. In his notes for a 1958 talk at the Institute of Contemporary Arts, London, he wrote:

DISINTEGRATE
An image is cut out of a newspaper; shall we say a blurred news
photo, flashlight taken in the rain, of a crashed aeroplane.
A battered wheel rises sharply in the foreground near a happy
face, a cowling like an eye waits in the vegetation.

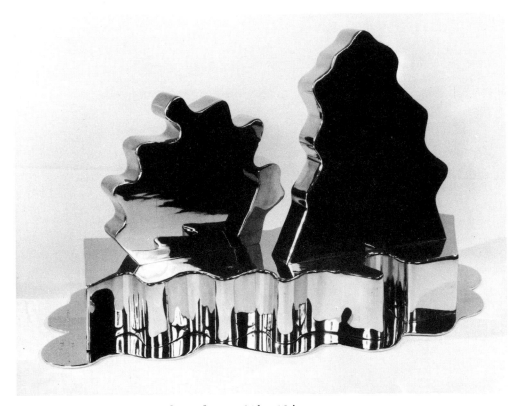

65　*Trio* 1964–5, chromed steel, $18 \times 31\frac{1}{2} \times 13$ in.
Private collection

Twisted and pulled　still recognizable　crashed JUNKER
part of the anatomy/fuselage exposed like a wounded beast
zinc-alloy piece filled with Scottish clay
Fragment of an autobiography

This image found little direct echo in the works of the later 1950s. With
the development of the machine-style of the early 1960s, Paolozzi evi-
dently finally found the means to give a three-dimensional artistic
expression to the idea. The result is *Crash*. Disintegration of an imagined
original mechanical structure seems complete: the various elements are
bent, twisted, broken, wrenched cruelly apart. The piece actually has
one long horizontal axis. But the axis is interrupted, and the forms above
it weave off into space at several angles. The image goes further than the
described photograph of the crashed Junker plane, for the strobe-lit
image was made after the plane had impacted and the débris had settled.

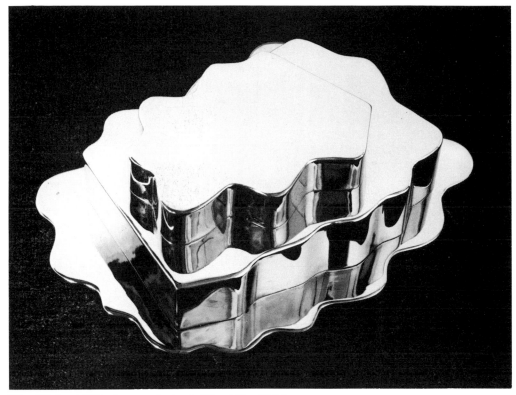

66 *Hidra* 1966, chromed steel, $15 \times 44\frac{1}{8} \times 18\frac{1}{8}$ in.
Private collection

With *Crash*, there is more the feeling of being an eyewitness to the moment of the crash itself. Gravity seems suspended. Welding makes possible such an apparent freedom from the laws of nature, and the artist has happily exploited the technical possibilities to express the moment before complete disintegration.

The snaky twisting pipes which create *Crash*'s image of explosive action may reflect Paolozzi's interest in the Hellenistic *Laocoön* sculpture group. But also, by the time he had finished *Crash*, Paolozzi had developed an expanded vocabulary of machined units which allowed him an increasing compositional freedom. The curving sections of half-round tubing which formed the sinuous ligaments holding the parts of *Crash* together become pliant legs of upright machine personages like *Medea*, 1964 (plate 53). These legs writhe along the ground and through space like aluminium spaghetti or exploring metal tentacles. *Medea*'s whole figure has a quality of stealthy, slithering movement which may

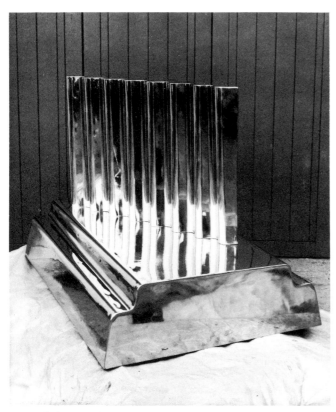

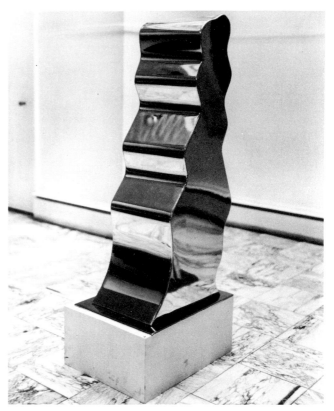

67 *Nakamunk* 1966, chromed steel, $34\frac{1}{2} \times 49 \times 44$ in.
Collection the artist

68 *Molik* 1967, chromed steel, $43\frac{1}{8} \times 16 \times 20$ in.
Private collection

have inspired the title. The sinuous contours of *Parrot*, 1964 (plate 54), suggest some of the dancing figures of Indian sculpture. The snaky tubular limbs of these works are a continued expression of the image of the *New Laocoon*, but now the executioner serpents are merged with the figures of their victims. However, Paolozzi's new machine-style presences are not wholly sinister beings. There is something rather charming and endearing in their posturing. The shapes are marvellously familiar and strange at the same time; they recall both Disney cartoon animals and descriptions of some of the alien creatures invented in the pages of science fiction. Paolozzi has an extensive collection of material related to Mickey Mouse, and he consciously borrowed details like pipe-stem legs, spherical bodies, and circular ears for some of the cavorting forms in his 1964 idea sketches. He also remained a science fiction fan and

undoubtedly read some of the multitude of stories produced in the late 1950s and early 1960s which dealt with the encounter between man and alien. The literary preference of the period required examining the psychological aspects of a meeting between man in human form and intelligent non-human life in a shape as unlike that of man as the writer could imagine. Since imagination must begin with the known and leap from that into the unseen, the inventions usually had recombinations of earth animal anatomy. Favourite selections were those which would occasion uneasy comparison with the human body: reptilian limbs and skin, faceted eyes, antennae, and multiple or oddly shaped breasts. Paolozzi's machine-style figures of 1964 and 1965 have machined versions of most of these.

In 1964 Paolozzi also opened up his tower-figures by creating a permutable group of six architectural presences which he called *Rio* (plate 52). The units of this piece were mostly 'cannibalized' from earlier destroyed works. (Paolozzi has always been a rather severe destroyer-critic of his own work.) When the six pieces of *Rio* are placed together with their bases touching, the animated stacks of boxes and tubes suggest a futuristic cityscape. Gone is the hieratic symmetry of the earlier tower-figures. Now there is a complex interweaving of void and mass as space flows through the 'streets' and around each structure. In 1966 Paolozzi created a second permutable sculpture, *Hamlet in a Japanese Manner* (plate 47). Its composition is probably the loosest and most complex of any work Paolozzi has ever conceived. The three sections swing through space on a multiple axis which shifts with each new unit arrangement. No matter how the pieces are placed, the work always balances on the thin line between complex unity and complete confusion. Paolozzi intensified the visual complexity by painting the work with a colourful 'camouflage' pattern of meandering free-form designs. In some arrangements, the paint patterns batter the forms and the result approaches a visual overload. However, Paolozzi has never been primarily concerned with working out a formal space-mass relationship. He is first and foremost an image-maker, a creator of 'living' totems which stand in space rather than formally uniting with it. He succeeds so completely that seeing two or more of his pieces together is like glimpsing a fragment of a weird, stylized drama (plate 41). The permutable tripartite image of *Hamlet in a Japanese Manner* is a drama complete in itself. In different groupings, the work projects different tableaux of presences, scenes from a stage play for machines. The impression of theatre is reinforced by the title's reference to the presentation of Shakespeare's play (or character) in an oriental manner. One thinks simultaneously of the ritual traditions of Japanese Noh and Kabuki theatre and of Japan's reputation for industrial skill and for borrowing and improving on western designs.

As part of his experimentation with the machine-style, Paolozzi also

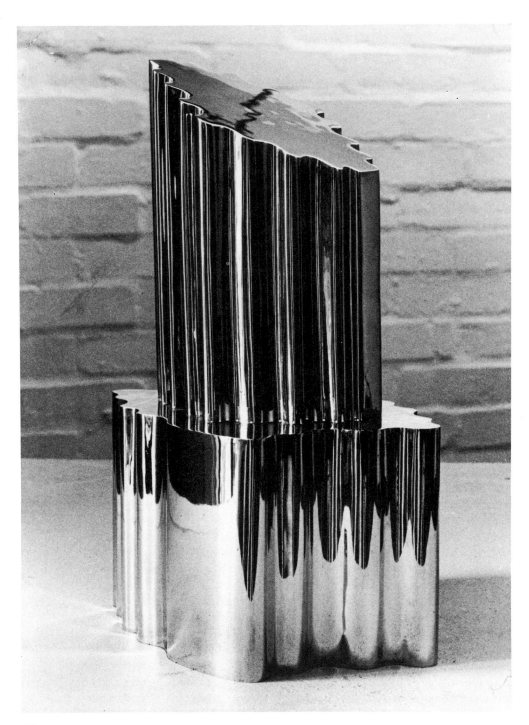

69

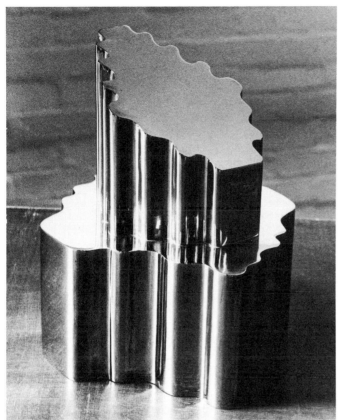
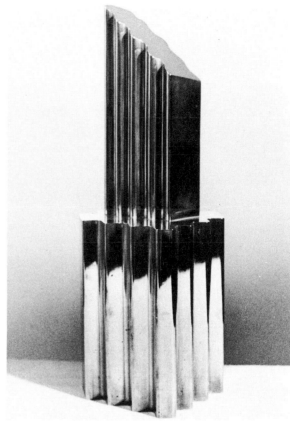

70 71

69, 70, 71 Recent polished bronzes, 1968–9. Collection the artist

explored the possibilities of chromed steel and polished aluminium surfaces to increase the visual magic of his sculptures. He designed new unified compositions with gleaming, bumpy surfaces to exploit the soft highlights and shadows of the polished aluminium. *Akapotik Rose*, 1965 (plate 57), is essentially a long wall and yet it has much of the free movement through space of intricate works like *Karakas* or *Crash*. The main body of *Akapotik Rose* has three undulating 'fence' sections stacked one on top of another. Each storey is twisted slightly off the axis of the storey beneath and displaced sideways to form a cantilevered, stair-step pattern. Each has a different reflective relief surface which destroys much of the sense of solid wall mass. Tube-antennae sprout from irregular star planes atop the whole wall. Here Paolozzi created a memorable new sculptural presence. It is unlike the earlier machine presences.

When seen from above, *Akapotik Rose* resembles a strange blossom (hence the title?); from any viewpoint on the ground, it has a quality of alien gesture. However, the forms are not rearranged echoes of terrestrial zoology like those in *Medea* or *Parrot*. The fence sections seem able to pivot independently to any position, the stiff antennae seem to be in the process of receiving, sensing, and acting upon data from the environment. There is a sense of machine presence, not the earthly console machines of the early 1960s but an awesome alien technological personage. The gesture-pose reveals, becomes, and *is* the sculptural presence. From 1964 on Paolozzi made a series of sculptural gesture-personages in all media. He developed a new machine-unit shaped like a flanged cell from a giant mechanical honeycomb. This gave him a new flexible vocabulary with which to build lyrical wall presences like *Pan Am*, 1966 (plate 55), or stately compositions like *Es Es*, 1966 (plate 59). He combined fence units and huge cylindrical pipe sections into imperious gestures like *Ovemk*, 1966–7 (plate 56). He used smaller tubes to design langorously stretched-out tube personages like *Gexhi*, 1967 (plate 62). And he even used most of his new aluminium units to make the ten 'words' of *Domino*, 1967–8 (plate 58), which leaves the actual creation of the 'sentence' or sculptural gesture to whoever wishes to arrange the parts.

Chromed steel inspired Paolozzi to make very different designs from those for his polished aluminium works (plates 63–68). Most of the actual chromed steel shapes are simple, closed, and monolithic. However, visually, the chrome-surfaced pieces are dissolved by their environments. With the mirror finish, Paolozzi found a new means of creating the complicated surfaces which have fascinated him since his student days. The chromed sculptures are calm and impassive receivers of reflections from their surroundings. They respond to changes in the viewer's position by alterations in their apparent shapes which modify their formal meaning. The interplay of reflections from one shape to another creates an ambiguity of surface and form which imparts an aura of visual mystery to most of the chromed works. All the chromed works are beautiful objects. The best seem like incarnations of bewitching technological splendour. They are the extension into an industrial vocabulary of the sensuous beauty developed by artists like Brancusi and Moore to express the essence of living organic forms. Each of Paolozzi's pieces is hand-made by industrial techniques. The units are made from rolled sheet steel which is cut and bent to the artist's specifications (plates 60, 61). Narrower side planes are often fashioned into intricate ripples or waves. Larger top, front, and side planes are usually formed into sweeping curves, with occasional bumps or creases to vary the reflecting patterns. Planes and strips are welded together into single forms. Two or three units are fastened together to form a final composition. The finished steel piece is then sent to the chromers for its final metal coat.

The basic shapes of some of the chromed pieces like *Daola*, 1967 (plate 63), or *Amir-Amur*, 1967 (plate 64), invite comparison with the spare forms of American primary structures. But minimalists such as Judd or Morris strive to create compositions which evoke no association or meanings beyond the fact of their physical formal presence. Paolozzi's chromed steel pieces remain always characteristically and persistently multi-evocative. *Trio*, 1964–5 (plate 65), has two 'figures' set on an 'island' which rises from a shiny 'puddle sea'. *Hidra* 1966 (plate 66), might be the direct personification of some jeweller's cartographic fantasy, while *Nakamunk*, 1966 (plate 67), could be a millionaire's lavish washboard. The irregular contours of *Molik*, 1967 (plate 68), suggest a forward flowing movement somewhere between the jerky motion of an animated cartoon figure and the progress of a microscopic creature on a slide under a high magnification viewer.

The formal and optical fascinations of Paolozzi's work in chromed steel and polished aluminium inspired him to begin investigating the possibilities of using glass in sculpture. His interest in glass was further stimulated by several picture books dealing with the imaginative architectural use of glass in the 1920s and 1930s in Germany and the United States. With his usual thoroughness, Paolozzi began to amass a file of technical material for his possible future experiments with the medium. He also arranged some preliminary conferences with a leading British glass manufacturer on the possibilities of using production facilities like theirs for such work. And he produced some sculptures and models for possible translation into glass at some later date. But, at present, these projects are in abeyance. Recently he completed a giant work in stainless steel, on location, for Expo 70 in Osaka, Japan (plate 50). But most of his latest sculpture is smaller in scale and designed in polished bronze (plates 69–71). Many of the bronze compositions develop ideas explored in some of the chromed steel pieces. But the method is different. Units are made in plaster and combined in various compositions for the final bronze sculptures. The plaster elements have many sources, from traditional casts of various found objects to casts taken from moulds made by newer techniques like vacuum-forming and blow-forming.

Experiments in communication:
the non-sculptural work of the 1960s

The bronzes are only one small part of Paolozzi's present creative activities. He has also been experimenting in ceramics, print-making, writing, electronic sound, and cinema. Much of this work is concerned with developing ways to use 'found objects' from the various mass media which are an integral part of the present western urban environment. Usually Paolozzi's method has been to make a type of visual or verbal idea-collage. He has been an idea-collector from his Slade student days. By the early 1950s, many of the items in his growing files were images from the mass media. Of course, the ideas of 'mass-comm' and 'mass-ad' were very much in the air at the time. Schwitters had used comic strip sections in a 1947 collage, Bacon began using book and magazine photos and movie stills as 'models' for his paintings of the late 1940s, and Barbara Johnson and Tom Ingram included examples of 'popular art' in their 'Black Eyes and Lemonade' exhibition at the Festival of Britain in London in 1951. Sporadically, Paolozzi sought ways to incorporate mass media imagery into his own work. He made a series of collaged books and sheets from items that interested him. In 1952 he selected a special group of images from the pages of glossy magazines and projected them one after another for a meeting of the Independent Group in London. The images ranging from a Swank man's jewelry advertisement from a 1938 magazine, through sheets of US Army aircraft insignia and a Disney cartoon page entitled 'Mother Goose Goes to Hollywood', to a scene of New York skyscrapers with a liner steaming up a background river, a gorilla holding a swooning damsel, and a bumpy robot pouring coffee for a scantily clad example of feminine pulchritude. The slides were projected in random order, the better to heighten the parallel with actual daily information input. In 1954 Paolozzi made at least one image, *Two Portraits* (plate 73), which contained the embryo of his idea-collage style of the 1960s. The background of *Two Portraits* is part of a page from an Italian newspaper, placed upside down. Pasted over it are magazine-cover portraits of Igor Sikorsky and Lewis Strauss. The faces have been altered by collage: Sikorsky sports new huge eyes and dark-rimmed glasses, while Strauss has been robbed of individual facial features. The inverted columns of newsprint and the two portraits retain their separate visual integrity. At the same time they are welded into a composition which evokes many meanings. Here are the seeds of a style with which Paolozzi could express what he terms the 'schizophrenic quality of life'.

84

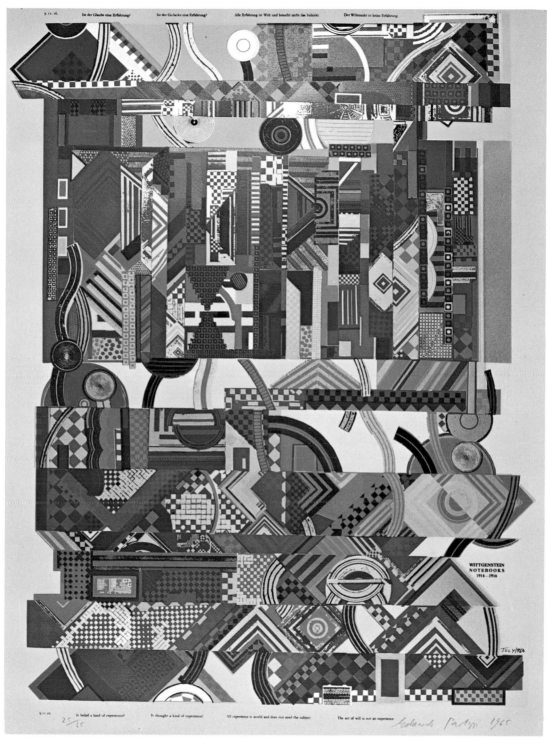

72 *As Is When: Experience* 1964–5, screenprint (edition of 65), 32 × 22 in.
 Published by Editions Alecto, London

73 *Two Portraits* 1954, collage
 Private collection

In the 1960s he expanded the possibilities of this style in his graphic
works, writings, and films.

In the early 1960s Paolozzi made a black and white movie called *The
History of Nothing*. In it he created a surrealistic fantasy by shooting
a vast series of special collages with single-frame animation. This was
not his first venture into cinema. In the 1950s he had made an experi-
mental collage film with some friends on a British Film Institute grant.
The earlier film was a collection of 'found' fragments from motion
pictures in the Institute's archives. The earlier work thus differs from
The History of Nothing which was made entirely from still images. The
animation technique gave Paolozzi greater control over his cinema, for
he could experiment with each frame if he wished, which allowed him a
greater freedom and spontaneity in the creation of the final movie.
Much of the imagery of *The History of Nothing* was taken from old books
and magazines. This gives the film an aura of layered experience domina-
ted by nostalgia and memories of the past. The movie bombards the

viewer with a series of disparate images which trigger a 'story-making' response in the brain. The technique is similar to that used by cinema experimenters from Méliès on to exploit the peculiar reality created in the perceiver's mind from a sequence of unlike images. Apparently, if no logical link can be made, the brain draws on all the resources of its conscious and unconscious files to create an intuitive connection. The resulting 'vision' often suggests a wider glimpse of the whole of reality than any sequence which could be promulgated by the limited conscious mind alone. The Dadaists and Surrealists had capitalized on this trait to produce their strangely true art. Paolozzi wanted to link the inner dream world of man's subconscious with his conscious mental life and his external physical existence.

The film's title is essentially a philosophical joke which reveals much about Paolozzi's approach to the communication of ideas. The usual historical method is a linear one, often based on a chronological framework and linked to a general concept which fosters a clear structure for the presentation of the data. 'The history of nothing' would imply a non-linear presentation based on no one concept or thing. The movie is an idea-collage of images which touches many places, times, and thoughts. Some of the stills were 'found' photographic images, a few were Paolozzi prints, most were collages the artist created especially for the film. Details were selected from heterogeneous files Paolozzi had built up over the years by culling evocative images from newspapers, magazines, catalogues, work books, sample books, and every other available source. The final collages were varied, ranging from fairly simple patterns to complex compositions with witty juxtapositions of different photographic images and patterns.

Perhaps the most haunting and memorable of all *The History of Nothing* collages are the fantasy scenes. In one, a female nude emerges ghostily from the wall of a medieval church. In others, whimsical machine beings are installed in 1920s/1930s interiors (plate 76), placed in outdoor urban scenes, or transformed into architectural monuments in photographic landscapes (plate 77). Paolozzi has said he agrees with Orson Welles that 'there is no Nowhere'. Any visualized place, however 'imaginative', must be fashioned out of known artifacts or things, and these transfer their own auras and histories to the imagined place. Such a process creates the strangely powerful reality of Paolozzi's collage scenes. The spirit of many of the film collages is close to that of certain images from Max Ernst's collage novels. Like Ernst's works, Paolozzi's movie stills are pure collages in which the artist's hand is seldom seen.

When the stills for *The History of Nothing* were finished, the process of creating the actual film began. The artist prepared a shooting script and enlisted the aid of film-maker Denis Postle to help transform the stills into cinematic form. Paolozzi published a 'Shooting Script' related to the film which captures something of the viewing experience:

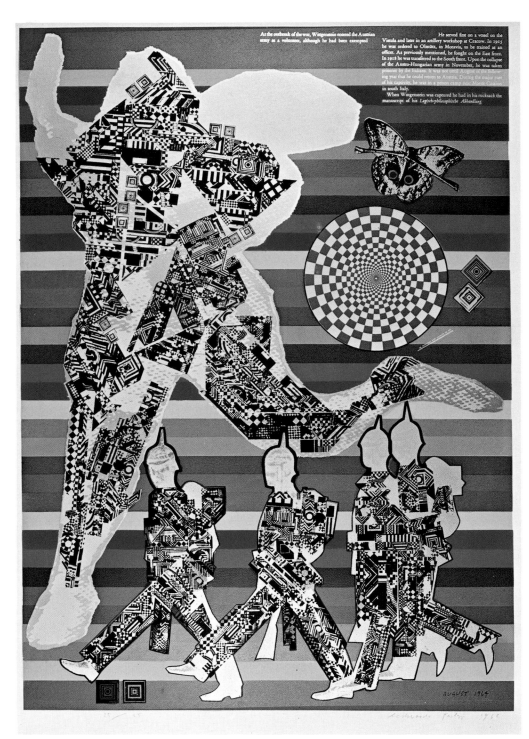

74 *As Is When: Wittgenstein the Soldier* 1964–5, screenprint (edition of 65),
 32 × 22 in.
 Published by Editions Alecto, London

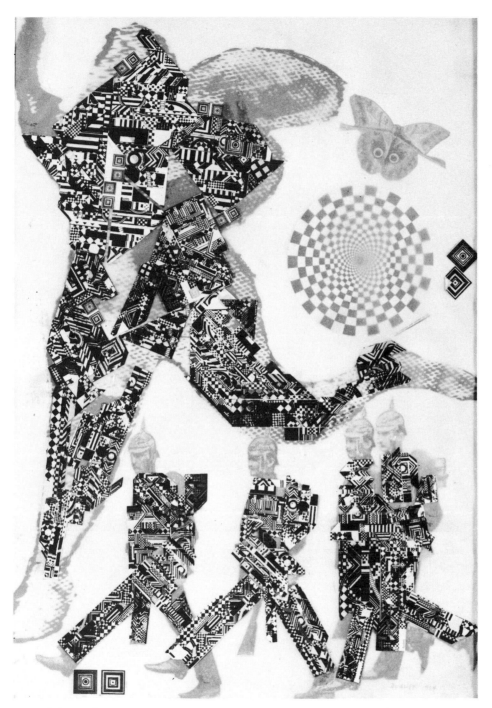

75 Collage for *As Is When: Wittgenstein the Soldier* 1964, 30½ × 21⅛ in.
Museum of Modern Art, New York, gift of Mrs Gabrielle Keiller

76 Still from *The History of Nothing, c.* 1961–2, collage, $7\frac{3}{4} \times 5\frac{3}{4}$ in. Collection the artist

77 Still from *The History of Nothing, c.* 1961–2, collage, $8\frac{1}{16} \times 5\frac{3}{8}$ in. Collection Colin St John Wilson, Cambridge

PAN INTO Variegated mask Distorted lunatic cat Actual
laboratory rat Madonna silhouette with centurians shield

CLOSE UP Flag sequence with folding screen Raised relief
like dead volcano

MIDDLE SHOT Open diamond Patterns double ribbed fantasy
Inca outline Gothic door

LONG SHOT Ruined engine in cityscape Striped diagonals
containing six squares Pyramid persuasion

DISSOLVE Wide shots Clock design Overlapping edges
Triangular structure supporting maltese fan containing cor-
inthian box Camouflage patterns Flower gives way to
circular stretched idea preparing for an ancient senator
topped with an electrical measuring dial Jump to a plastic
anonymous clock collage in tiled interior Collage of mech-
anical elements on a page from an ethnographic journal
Superimposed drum Foundation ford Ready made printed
circuit with real presence Large switch in an interior,
this is from a book illustrating what seems to be some luna-
tic institute Camera pans up a church tower Diamond bar
with solemn knot in centre

SHOOTING SCRIPT WITH WILD TRACK

FIRST SHOT Elektrik wheels in baroque frame (overlapping
cultures)

LONG SHOT Clowns and dancers Robots aeroplanes ancient
and modern Demolished ships Diamond transformations and
German transformers dissolve

MIDDLE SHOT Radial engine Floral gears Useful analogy
military insignia transfer Lagoon seen through cars wind-
screen Aerial view of a city burning

CLOSE UP Silver skull Jointed hands Articulated breasts
Decorated trumpet Concrete dragons teeth

FADE OUT On toy railway signal merging into Mount Olympus
Details of iron bridge
(Paolozzi, *Metafisikal Translations*)

In the film, images appear more than once, and a variety of techniques were used to create the sense of cinematic movement. The viewing experience involves approximately twelve minutes of concentrated reception of changing images and meanings. Sometimes the camera was panned across a still. Sometimes the lens zoomed in to a close-up of one detail or backed away for a long shot of the whole. Often, an interior montage was created by cutting from one detail to another. The shift from one image to the next was always done with a superb feeling for witty formal play and for evocative symbolic possibilities. The film creates a flowing evanescent dream imagery in which surrealist reveries merge with urban, industrial, and technological fantasies.

In the early 1960s, Paolozzi also began exploring the possibilities of various graphic arts for creating visual idea-collages. While teaching in Germany in 1961, he designed some photolithographs based on single or juxtaposed 'found' images from catalogues and mass media. In 1962, he began working with silkscreen in England. As part of the experimentation, he re-worked several of his photolithograph designs into colour screenprints. To produce the silkscreens Paolozzi enlisted the help of Christopher Prater, a master screenprinter, who owned and operated his own facilities, Kelpra Studio in London. Gradually, together, artist and printer expanded the potential of the traditional medium. Paolozzi's earliest colour screenprints had fairly simple designs with bold clear colour areas which required a small number of individual hues and relatively few middle tones. In his dual role as client and ideas-man, Paolozzi kept asking Prater and his assistants for greater versatility in translating collages into screenprints. Soon they were using up to sixteen colours on one print and had developed great expertise in the application of photographic processes for making screens.

One of Paolozzi's first major screenprints designed for this mature technique was *Conjectures to Identity*, 1963 (plate 78). The work was part of a project in which the Institute of Contemporary Arts proposed to commission silkscreen prints from twenty-four contemporary British artists. *Conjectures to Identity* was Paolozzi's most complex image-collage to that date. The design included bits of pattern paper, mechanical illustrations, and a photograph of people worshipping before a crucifix on an altar. Each image in the print retains its independent visual existence while still belonging to the larger whole. The work was printed in several colour variations by altering the order in which inks were applied and by changing hues for individual stencils on succeeding pulls. Later, Paolozzi and Prater extended this method to allow each print in an edition to have a unique colour combination.

In his prints of the 1960s, Paolozzi was developing a new personal 'linguistics' of visual imagery. It had links with some Surrealist experiments with chance combinations of words or images. It also may have owed something to the ideas of the Austrian philosopher Ludwig

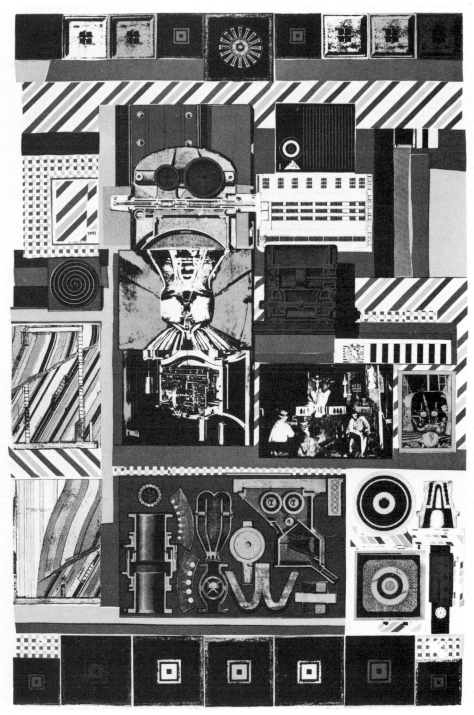

78 *Conjectures to Identity* 1963, screenprint (edition of 40), 30 × 19 in.
Commissioned by the Institute of Contemporary Arts, London

Wittgenstein, whose works Paolozzi had read with intense interest. In *Philosophical Investigations*, Wittgenstein had developed the theory of language-games. A Wittgensteinian language-game is the way in which the units of a language are used for a given purpose — asking questions, giving orders, etc. Paolozzi's print images not only seem to be concerned with developing optical language-games, but to be the visual expressions of another Wittgenstein theory (set forth in his *Tractatus Logico-Philosophicus*) that a verbal proposition is a 'picture of reality'. Paolozzi, in his prints, seems to use his new visual 'linguistics' to construct 'image propositions' which would be similarly true pictures of reality, in the Wittgensteinian sense rather than, or instead of, in the traditional way.

The importance of Wittgenstein's thought for Paolozzi may be directly seen in the series of collages the artist made during 1964 and 1965 based on the life and writings of the philosopher. The collages were transformed into a portfolio, *As Is When*, which contained twelve screenprints and a poster (plates 72, 74, 75). The group was published by Editions Alecto, London, and printed by Kelpra Studio. Nine of the twelve prints were based on Wittgenstein's thoughts; the remaining three were based on his life. The three biographical prints are figurative; the nine designs linked to his ideas are more abstract. All the prints incorporated pertinent quotations from Wittgenstein's writings or from the biographies by Norman Malcolm and George von Wright. The selection of Wittgenstein's ideas forms an interestingly complete artistic statement which furnishes a key to the understanding of much of what Paolozzi has done in the 1960s.

Artificial Sun contains a short text which is the theme of the entire portfolio: 'THE WORLD IS ALL THAT IS THE CASE'. The print's title is a 'found' phrase, probably clipped from an advertisement. Like most of the other print titles in the portfolio, this phrase has a suggestive poetry which sparks speculative thought about its meanings. One begins to ponder which pattern or photo images are the artificial sun, what *is* an artificial sun, how does it relate to the world if 'the world is all that is the case', what place do stripes and dots and geometric shapes have in this world, etc.

The speculation is amplified in the second print. *The tortured life of an influential modern philosopher, the late Ludwig Wittgenstein* has a collage text which refers to Wittgenstein's inspiration for his thesis that a proposition is a picture of reality:

> Wright, one day in a trench on the eastern front while he was reading a magazine in which there was a picture of the possible sequence of events in an automobile accident. The picture, he said served as a proposition where parts corresponded to things in reality, and so he conceived the idea that a verbal propo

sition is in effect a picture. By virtue of a similar correspondance between its parts and the world. In other words, the structure of the proposition 'depicts a possible combination of elements in reality, a possible state of affairs'. The Tractatus

The proposition: 'There is no hippopatamus in the room at present?' When he refused to believe this, I looked under the desks without finding one; but he remained unconvinced.

Let us ask the question: 'Should we say that the arrows →&← point in the same direction or in different directions?' At first sight you might be inclined to say 'of course in different directions'. But

The text and the design of the print seem equally fragmented. Yet the intricate visual patterns do form structures, and the structures undeniably create a picture. The text speaks of verbal propositions whose parts correspond to things in reality. One is led to consider the possible nature of similar optical propositions which could serve as visual analogues in the same way that Wittgenstein's verbal propositions do.

The accompanying text of *Experience* (plate 72) takes a further step by considering experience, which is an essential part of understanding pictured reality:

9–11–16 Is belief a kind of experience? Is thought a kind of experience? All experience is the world and does not need the subject. The act of will is not an experience.

What is the artist's subject? 'The world is all that is the case'. 'The structure of the proposition "depicts a possible combination of elements in reality . . ." ' 'All experience is the world and does not need the subject'. In the print, the visual pattern is a series of horizontal strips, each filled with an intricate and richly varied collection of pattern fragments. The patterns appear to blend, shift, and even to oscillate backward and forward in space. They might be visible thoughts, symbols for experience unlimited by a finite physical subject.

Reality has a quotation which deals with the relationship between reality, the world, and the picture:

2(06) The sum total of reality is the world.
2 1 We picture facts to ourselves.
2 11 A picture presents a situation in logical space, the existence and non-existence of states of affairs.
2 12 A picture is a model of reality.
2 13 In a picture objects have the elements of the picture corresponding to them.
2 131 In a picture the elements of the picture are the representatives of objects.

2 14 What constitutes a picture is that its elements are related to one another in a determinate way.

2 141 A picture is a fact.

The composition of *Reality* is broken into separate sections, each a whole, juxtaposed with other units: the divisions are clearer, less inter-linked than those of *Artificial Sun, Tortured Life,* or *Experience. Reality* seems to be a more self-conscious picture of Wittgenstein's 'picture', whereas the other prints were pictures of less clearly developed ideas.

Parrot bears a text which suggests that the philosopher's (artist's) task is to make one aware of the multitudinous levels of meaning available in any expression:

> What I give is the morphology of the use of an expression. I show that it has kinds of uses of which you had not dreamed. In philosophy one feels *forced* to look at a concept in a certain way. What I do is to suggest, or even invent, other ways of looking at it. I suggest possibilities of which you had not previously thought. You thought that there was one possibility, or only two at most. But I made you think of others. Furthermore, I made you see that it was absurd to expect the concept to conform to their narrow possibilities. Thus your mental cramp is relieved, and you are free to look around the field of use of the expression and to describe different kinds of uses of it.

Parrot contains a more definite 'figure' than the other 'idea' prints. Yet the figure, composed primarily of triangles, stripes, and curved sections, does not immediately fit the designation 'parrot'. So one begins to ponder the various possible meanings of parrot, a process which, in itself, effectively illustrates the text on the print.

The meaning of the title of *Futurism at Lenabo* is elusive. It does not refer directly to the text. The layout of the print resembles a page from an abstract futuristic comic book. The text suggests further 'readings':

> It is worth noting that Wittgenstein mentioned that a serious and good philosophical work could be written that would consist entirely of *jokes* (without being facetious). Another time he said that a philosophical treatise might contain questions (without answers). In his own work he made use of both. To give an example: 'Why can't a dog simulate pain? Is he too honest?' (Philosophical Investigations 250)

Humour had long been an element in much of Paolozzi's work, and it had sometimes succeeded in operating in the manner suggested by Wittgenstein. The serious use of irony increases in Paolozzi's later work, like

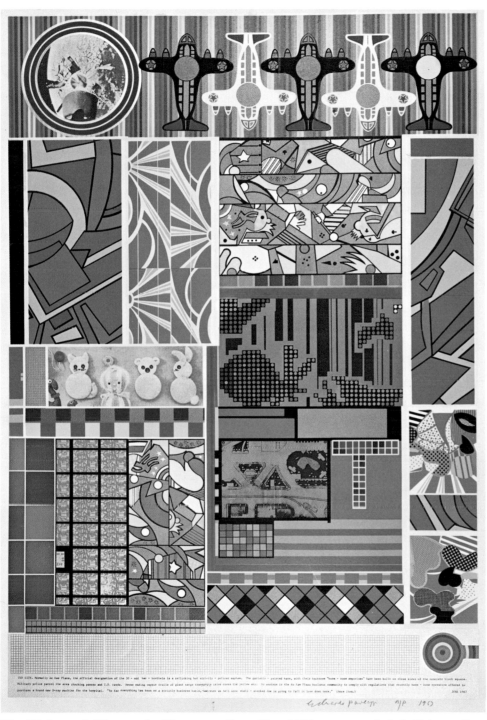

79 *Universal Electronic Vacuum: Sun City* 1967, screenprint (edition of
 75), 40 × 27 in.
 Published privately by the artist 97

Moonstrips Empire News and the collages for *General Dynamic F.U.N.* which are simultaneously pictures of the reality of modern life and critiques of that life.

The text of *Assembling Reminders for a Particular Purpose* discusses the role of the philosopher (creative thinker, picturemaker of reality):

> 126. Philosophy simply puts everything before us, and nowhere explains nor declares anything — since everything lies open to view there is nothing to explain. For what is hidden, for example, is of no interest to us. One might also give the name 'philosophy' to what is possible before all — discoveries and —

> 127. The work of the philosopher consists in assembling reminders for a particular purpose.

Paolozzi's assembled visual and verbal reminders in his works through out the 1960s have been for his particular and various purposes. For the attentive viewer, who will learn his language-games, 'everything lies open to view there is nothing to explain'.

The Spirit of the Snake has a text which seems to echo some eastern philosophy. It considers man's understanding of other species in the world. Possibly, by extension, it may be a clue also to the understanding of the pictures of reality which creative thinkers formulate:

> Only remember that the spirit of the snake, of the lion is your spirit. For it is from yourself that you are acquainted with all. Now of course the question is why I have given a snake just this spirit. And the answer to this can only be in the psychological parallelism: If I were to look like the snake and to do what it does then I should be such-and-such. The same with the elephant, with the fly, with the wasp.
>
> But the question arises whether even here, my body is not on the same level with that of the wasp and of the snake (and surely it is so), so that I have neither inferred from that of the wasp to mine nor from mine to that of the wasp.

It is perhaps natural that Paolozzi, given the quote, should have included two small portrait photographs of Wittgenstein in the lower left section of this print. Again there are multiple suggestive links between imagery and text, and each person's 'reading' may be different as each person may have a slightly different experience of the spirit of the snake, the elephant, the wasp, and himself.

The text of *He must, so to speak, throw away the ladder* is intended as a hint that the final understanding of reality, or even of pictures of reality, comes with a leap beyond reason or logic, and above all, beyond words:

My propositions serve as elucidation in the following way: anyone who understands me eventually recognizes them as nonsensical, when he has used them — as steps — to climb up beyond them. (He must, so to speak, throw away the ladder after he has climbed up it.) He must transcend these propositions, and then he will see the world aright. What we cannot speak about we must pass over in silence.

In the nine 'idea' prints, Paolozzi develops a visual language and then, with it, evolves language-games, which can express the ideas. He seems to be trying to combine Wittgenstein's two major concepts about language (which Wittgenstein did not synthesize), by inventing new visual language-games which will be accurate pictures, in the Wittgensteinian sense, of reality.

Paolozzi plays a slightly different language-game in the three prints on Wittgenstein's life. For them, he combines images from the visible world into figurative designs in keeping with the narrative texts. For example, *Wittgenstein the Soldier* (plate 74) bears a text which describes part of Wittgenstein's service in the Austrian army during the first world war. The composition has four small silhouette soldiers and one huge cloudy 'soldier' at the left whose rucksack would identify him as Wittgenstein, complete with unseen manuscript of the *Tractatus*. The poetic blend of sharp and hazy imagery in the finished print is due to the unique collage technique Paolozzi employed for this one work. He pasted one layer of images (which are soft in the final print) on to the main support. Over this he fastened a sheet of tracing paper on which he created the patterns which remain crisply in focus in the print (plate 75).

In 1967 Paolozzi created another large portfolio, *Universal Electronic Vacuum*, with ten prints and a poster (plates 79, 80). Again the screen-printing was done by Kelpra Studio. As the title indicates, *Universal Electronic Vacuum* is especially concerned with computer technology. The letters of the title mimic computer type. These same letters are raised in relief across the cover of the aluminium container box. And one of the prints is called *Computer Epoch*. Many of the images and their incorporated 'found' texts also reflect the artist's interest in computer graphics.

The titles of the prints are taken from their texts. Each creates evocative multiple meanings. Possibly the most complete 'poem' in itself is *883. Whipped cream, A Taste of Honey, Peanuts, Lemon tree, others*, which was originally advertising shorthand for one selection from a mail-order record club. All of the prints make some comment about modern life. The most pungent are probably the ones connected with the military facet of the present world. *Sun City* (plate 79) ironically combines stylized planes with a colourful collage of toy animals (from an Avon advertisement), a computerized image of a fish, rows of computer circuits, and various bright patterns which invest much of the print with a carnival gaiety. The text reads:

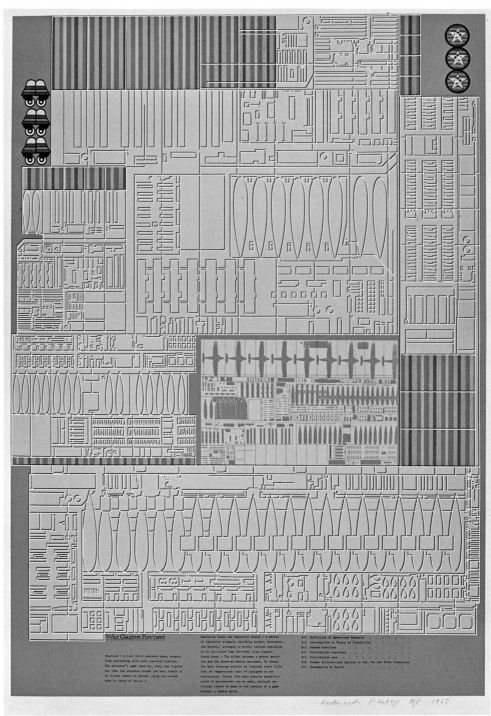

80 *Universal Electronic Vacuum: War Games Revised* 1967, screenprint
(edition of 75), 40 × 27 in.
Published privately by the artist

SUN CITY. Normally An Kee Plaza, the official designation of the 30-odd bar-brothels is a rolicking but strictly-policed region. The garishly-painted bars, with their backroom 'boom-boom operations' have been built on three sides of the concrete block square. Military police patrol the area, checking passes and I.D. cards. Never ending vapour trails of giant cargo transports criss cross the yellow sky. So anxious is the An Kee Plaza business community to comply with the regulations that recently boom-boom operators offered to purchase a brand new x-ray machine for the hospital. 'So far everything has been on a strictly business basis, but sure as hell some shell-shocked Joe is going to fall in love down here.' (News Item)

War Games Revised (plate 80) makes the most acid comment of all. Much of the surface has linear patterns which at first glance look like printed circuits. A closer look reveals many of the circuit diagrams to be bomb and torpedo shapes. One small rectangular inset has silhouettes of planes as well as bombs and torpedoes forming its 'circuit'. In the print's upper right corner are three stars, like those which tip the wings of US military aircraft; inside the stars are smiling heads of Mickey Mouse. The text might have been adopted equally from a military training manual or from the rule booklet of a modern war-strategy board game.

All of the prints in *Universal Electronic Vacuum* are collections of heterogeneous images with no single focal points. The layers of meaning must be perceived by a scanning process in which the brain freely uses the visual material to trigger memory responses and mental analogies from its own resources. This happens obviously with the figurative images and with the descriptive texts. But it also occurs in the perception of the abstract pattern designs. There is a simultaneous sense of exceeding neatness and of shifting forms and patterns in space. Modulations of colour, shape, and grouping make possible immediate pattern recognition and the playing with what one perceives. Colour chart hues are applied to pattern strips which resemble tape or cards punched by a digital computer. Several of the larger strip designs are parody quotes from Kenneth Noland's recent paintings, which in turn suggest awning patterns and mattress ticking. There is a sense of jewel-colours plus the sense of bright items on Woolworth counters. The elegant sophisticated appearance of the *Universal Electronic Vacuum* prints is also related to the kind of beauty Paolozzi was creating at the time in his chromed pieces. The style and materials of both sculpture and prints are linked to the use of chrome and metallic inks by manufacturers and designers as substitute materials for more precious stuffs. In Paolozzi's art there is a double twist, for he has adopted the media and part of the styling of mass-produced luxury items to his individual pieces; each chromed steel piece is unique and each print has an individual colour pattern which makes it that anomaly, the mass-produced original work of art.

Paolozzi has applied some of the ideas of the large prints to experiments in other media. He has made collages of abstract designs for patterns on a series of trial ceramic plates (plate 81). He has also re-worked sections of some of the screenprints for translation into large tapestries woven for him by the Edinburgh Weavers of Edinburgh, Scotland (plate 82). And in 1967 he used his expanded print techniques to create a complex 'book': *Moonstrips Empire News* (published by Editions Alecto and printed by Kelpra Studio). It was conceived as a giant file of text- and image-collages from the artist's voluminous collection (plate 83). One hundred loose screenprints are boxed in a formed acrylic container. Each viewer is invited to 'edit' the book by experimenting with various arrangements of the sheets in the box. Paolozzi has said that in *Moonstrips* he was concerned with the relationship between kitsch and technology. The colour combinations of the prints are elegant, including the prodigious use of gold, silver, and copper metallic inks. The moulded acrylic box has three choices of cover colour: bright yellow, bright green, and Dayglo pink. The images include movie strips and stills, scientific photography, industrial photography, weather photography, news photography, art reproductions, graphs, pattern papers, Disney cartoons and items from Madison Avenue's continuous fictionalized advertising Utopia for the common man. There are virtual reproductions of newspaper front pages, tables of contents, and dictionary clippings. And there are vast sections of collage text prepared specifically for this project.

During the past several years writing has become an increasingly important medium for Paolozzi. With *Moonstrips Empire News* and *Universal Electronic Vacuum*, he achieved a visual style which comes perhaps as close to incorporating time into the viewing process as any non-movie medium can do. In the verbal and visual collages of these works, each segment retains a unit identity stronger than the details in earlier Paolozzi works (and less bound to a total subject than the details of other art he has admired from that of Piero di Cosimo to that of Paul Klee). The collages must be 'read' by scanning; their richly layered meanings are released only as part of an experience in time. Most people in present urban society have been conditioned by movies and television to see visual images this way. Their techniques of image-reception have been expanded by now standard cinematic methods of montage, quick cuttings, split-screen, wipes, lap dissolves, and flash-backs. Originally these were all used to tell a story; more recently television advertising has adapted them for non-narrative selling. Now most viewers react to and enjoy the visual excitement of the style that McLuhan labels 'the medium is the message'. People who are 'turned-on' by quick-collage cinematic presentations respond to the dense visual imagery of Paolozzi's *Moonstrips Empire News* and *Universal Electronic Vacuum*. These same viewers, however, often have much difficulty in

'receiving' the collage texts. For although writers from Joyce on have been using conscious verbal techniques which essentially parallel the cinematic ones, these literary methods have not yet invaded the mass media to any significant degree. Most people still read in a mono-linear way, very slowly, word by word. The 'new writing' must be scanned rapidly to 'get its message', part of which is the revised medium itself. Paolozzi has always been a quick and omnivorous 'reader' of his environment, rapidly perceiving diverse images and texts. It is as natural for him to use the collage technique in his writing as in his prints; both stem from the same way of looking at the world.

Paolozzi's first published writing was 'Notes from a Lecture at the Institute of Contemporary Arts, 1958', which was printed in *Uppercase No. 1*. (The entire text of this article is reprinted in Appendix A, page 120.) The lecture was essentially an expository talk dealing directly with the artist's ideas and sculptural methods at that time. He prepared the text in a 'normal' fashion, combining English words in a straightforward way. Yet even here he often felt the need to condense, synthesize, string together long series of evocative words or phrases which would convey multiple meanings without the strain of interminable verbal explanation. For example:

SYMBOLS CAN BE INTERPRETED IN DIFFERENT WAYS.
The WATCH as a calculating machine or jewel, a DOOR as a panel or an art object, the SKULL as a death symbol in the west, or symbol for moon in the east, CAMERA as luxury or necessity. Acid etched, copper plated, dipped in liquid solder, the printed circuit, intricate, complex, evocative, as pretty as a Fabergé jewel. Modern polythene toys, due to the combination of plastic injection methods and steel dies, have a microscopic precision impossible to the handcraftsman of the past.

The words become units in a verbal collage and serve as metaphors for Paolozzi's whole creative process at that period. This was the beginning of the development of a literary technique which would fulfill the requirements he set forth in the 'Notes':

Key phrases, like key sculpture, take time to make. The arrival at plastic iconography is just as difficult as arrival at a language. A few sculptures per year can alter plastic values. A few statements can have a similar effect ... Avoid using worn cliches, the words that can't even indicate or scratch at the hundred hidden meanings in objects and structures ... The multi-evocative image demands a prose lyrical style at least. Anyway, an object which suggests a number of things might be described by the spectator in that order.

The next step in the development of Paolozzi's writing style was to devise a way of making the word-units more complete fragments in themselves. He wrestled with various solutions to this problem in *Metafisikal Translations,* a screenprinted volume he published in 1962. On one level, Paolozzi made this book an index to his contemporary work in other media: it contains references to *The History of Nothing* and to the early sculptures of the machine-style. Most of these passages use methods similar to those of 'Notes from a Lecture at the Institute of Contemporary Arts'. For example, in passages in *Metafisikal Translations* like the following excerpt from 'Notes on the Film The History of Nothing', words and phrases are strung evocatively together to create a meaning larger than the parts:

> The history of painting, The history of the object. The history of man can be written with objects.
> All sculpture is a man-made object. Machine as fetish Cylinder block Trojans column Lacoon
> As votive the crankshaft erotic Segments of information

Yet each fragment is more of a mysterious poetic entity in its own right than were the collage items in the ICA 'Notes'. The jump from one image to the next is now less consciously rational. There is more scope for each reader's brain to invent interconnections of its own.

In *Metafisikal Translations*, Paolozzi also experimented with other ways of loosening the absolute structuring of the text so that the reader might actively 'edit' the material as he assimilated it. The sections which most radically depart from traditional literary form are the passages in which Paolozzi tinkers with the spelling of words to load each unit with references to multiple things and to several languages. He creates ambiguous syntax and meaning by playing both with word order and with word appearance. Part of the text is set in standard type faces, large portions reproduce Paolozzi's written or printed notes, and several sections are printed in a deliberately crude style with a toy printing set. Paolozzi eliminates most punctuation from the text. He also eliminates most verbs and articles. The text is a collection of nouns, adjectives and adverbs, often formed into phrases. The words and phrases are strung together in an ambivalent order which implies several meanings. As a reader scans passages like the following, the 'messages' he picks up will vary with his linguistic background, his education, and his interests and experiences in general:

> DUAL ROLES DUALMOTIFS
> BOKHAS KHAN RINE MYCENAE
> MULTIPLIED F FACTORS TANK
> MIRAMAR PNEUMA-88 BANKI

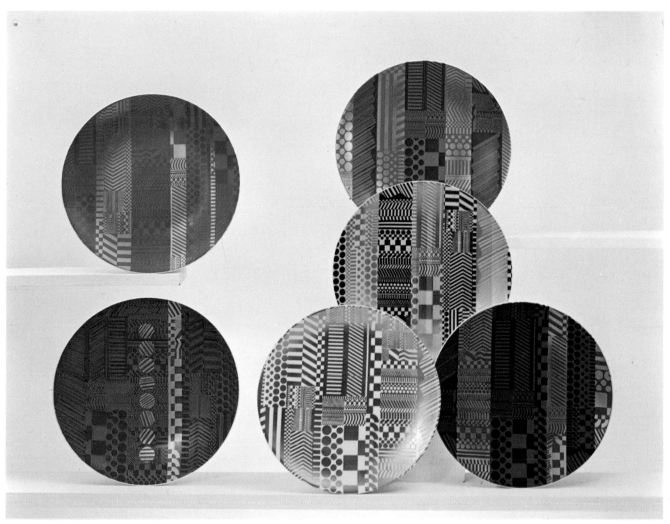

81 Group of ceramic plates, 1968–9 (six designs,
 each in an edition of 200) each 10 in. dia.
 Collection Josiah Wedgewood Ltd, London

CYCLOPEAN WALL TRAKTOR
DUB TEKNO GANZ MEANING
OF THE EPITHET U-BAD ON
DUAL MOTIFS ROLES DUAL IF

Since *Metafisikal Translations*, Paolozzi has widened the expressive possibilities of his collage writing style in a series of separate texts. *Wild Track for Ludwig The Kakafon Kakkoon laka oon Elektrik Lafs* was written for the *As Is When* portfolio. He constructed this text from the capacious files he had accumulated over the years by culling, from everything he read, passages or phrases which caught his eye. The actual writing process began with the editing of the 'found' fragments by changing an occasional word here and there. Then came the composition, often accomplished by spreading pieces over the floor and arranging them by a method half-way between conscious control and spontaneous intuition. Paolozzi speaks of the importance of this method as a way of stimulating the brain to create techniques which enable it to transcend its ordinary limitations so it can move freely in all directions. There is a relationship to the work of the French writer Raymond Roussel whom Paolozzi admired for the way in which he 'expanded ready-made phrases that he has chanced to find, almost like *objets trouvés*, in such a manner as to imagine a whole story.' (Roditi, *Dialogues on Art*) Some of the Surrealists also had explored the poetic evocation of illogical and random word combinations. But Paolozzi's writings have a quality all their own, like hallucinatory visions couched in the jargon of the popular press.

The text of *Wild Track for Ludwig The Kakafon Kakkoon laka oon Elektrik Lafs* reads like an adventure novelette told in a strangely disjointed style. It includes bits from an article about the Greek *Laocoön* sculpture, and selections from a text on film production, a war story about aviators and an essay on desert Bedouins. The intensity of the imagery is heightened because of the sharp shifts and interlinkings of passages. A brief excerpt will illustrate something of the tone and the method:

> The sense is here, however, nothing; the picture everything. Juxtapositions had been born. The plane is nearing the target. From the inner-phones comes the pilot's warning; 'Pilot to bombardier — On course and flying level'. As not placed, the sun seems fixed by the coils and base that join him and his father in a relief; hour on hour they kept up this busy whirl, stopping for neither meat nor drink, until finally the Bedouin's horses would drop in their tracks, and the riders would fall from their saddles, panting and exhausted.

Paolozzi also wrote a text for *Universal Electronic Vacuum* entitled *Mnemonic Weltschmerz with probability transformations (A systems*

study). It contained passages in both German and English, and the style and 'sense' were ironic echoes of that of the terse scientific writing found in specialized professional publications. (The complete text is reprinted in Appendix B, page 131.)

Paolozzi did not organize the portfolio texts into sections and paragraphs. He hoped this lack of structure would leave more possibilities for free personal editing by each reader. Unfortunately, few people have yet trained their minds to scan written material in this way. In addition, the texts of *As Is When* and *Universal Electronic Vacuum* were set in large type on the same large-scale sheets as the prints themselves. In this format, the passages are difficult to handle physically as well as to read.

Possibly the communication problems Paolozzi encountered with the readers of his first collage texts led him to develop the idea for his collage 'novel' *Kex*, published in 1966 by the Copley Foundation. (The mysteriously evocative title is actually the name of a Swedish candy bar.) During 1965, Paolozzi worked out huge batches of text for the novel and collected 'found' images for possible illustrations. The text was moulded into a shape which the artist hoped would more effectively convey his perceptions and ideas. He gave the text and the images to British painter Richard Hamilton, who acted as the final editor and layout man. Hamilton decided to organize the material even more tightly to give it a clearer, more polished, and more apparently logical format than was usually associated with Paolozzi's work. The finished book has a rather understated, elegant layout with crisp photographs, neat paragraphs, and intriguing chapter headings. It can furnish a good introductory lesson for anyone who wishes to learn to tap the wealth of Paolozzi's ever-growing body of writings.

The text of *Kex* contains a large number of first person narrative sections with descriptions of action and setting, yet the overall style is that of 'educational' articles in the slick magazines. The book contains passages from biography, thrillers, advertising for electronic equipment, movie reviews, and selections from articles on physics, history, education, ornithology, bombs, interior decoration, art, and astronomy. Some passages exude a serious erudite tone. Others seem more like parts of a poetic *avant-garde* novel. Two excerpts will illustrate something of this contrast:

> One may ask whether raising the gain of the warhead is always profitable. Generally speaking, the reduction to effectiveness owing to the necessary greater attenuation includes these 'idiosyncrasies' of growth, free theatrical, with the figures clad in fantastic garments, imitating butterflies or birds; or scenes of court life, with the figures of nobles or ladies, clothed in the still and many-folded brocade costumes of ceremony. Decoration, even in ballet, is over.

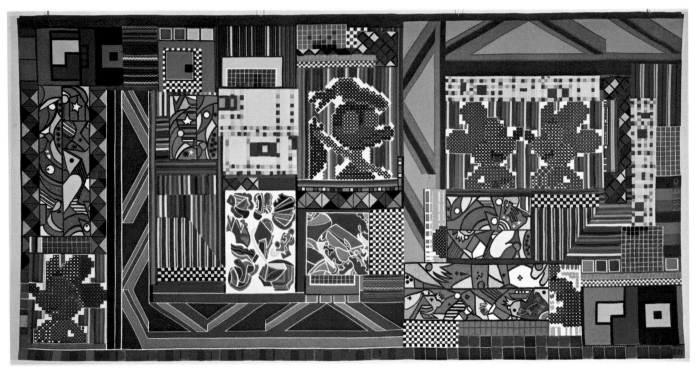

82 *The Whitworth Tapestry* 1968, wool, linen and terylene, 7 × 14 ft
The Whitworth Art Gallery, University of Manchester

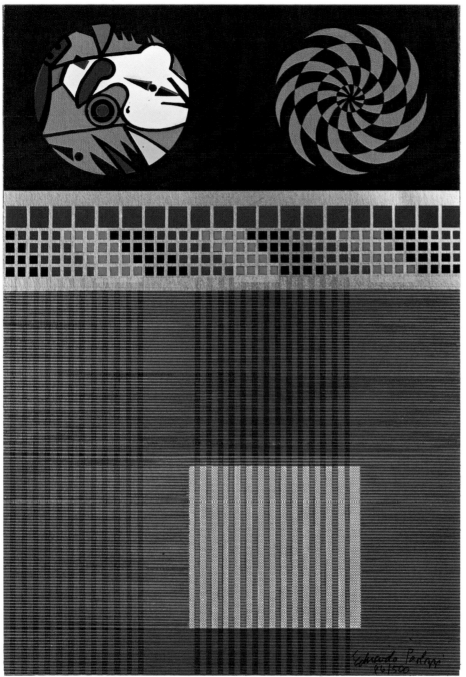

83 *Moonstrips Empire News: Memory Core Units* 1967, screenprint (edition
of 500), 15 × 10 in.
Published by Editions Alecto, London

It did not last long — six or seven minutes perhaps — but during that time Mme Sun tore one of her minute handkerchiefs into bits. The film shows dreams of butterflies, and now, with the prospect of a voyage before him, these delightful dreams grew and grew so that he saw the world filled with the radiant colours of butterflies' wings towards the heavens, ochreish toward the earth. Now and then you think the clouds are a fire, a long curious eerie white fire with a suggestion of green in it, as though some volcano had lit up the world below.

Paolozzi put the experience of *Kex* to good use in much of the voluminous amounts of text he prepared for *Moonstrips Empire News*. As in the majority of his writings, each word remains a unit in itself, often a self-sufficient idea-image. Yet each is simultaneously a part of a larger phrase or sentence which in turn is a unit. These units form parts of larger sections or paragraphs and ultimately all are submerged and welded into a total conceptual web. The words have become more important as actual visual designs too. In the text pages for *Moonstrips Empire News*, Paolozzi experimented extensively with typography and layout. Style, size, spacing, and layout of type is complicated by the use of various colours of ink on several colours of stock. The play with ease or difficulty of legibility becomes an important part of the text. In places narrow columns foster quick scanning and reading enjoyment; elsewhere broad paragraphs encourage relapse to slow, frustratingly linear perception. Sometimes the type is clearly visible, while on other pages the ink colour of the type fights or merges maddeningly with the background hues. The reader is invited in a hundred ways to become aware of the actual physical action involved in seeing and comprehending words. He also learns much about the mysterious processes of discovering how and why certain passages become more memorable than others for him.

The *Moonstrips Empire News* text is based on vast numbers of sources. There are tantalizing fragments to catch the interest of the most diverse readers. Once the eye and mind fasten on one passage, the reading habit takes over and the eye continues to drift over the page past the 'ending' of the chosen segment into its adjacent collage neighbour. With luck the content and/or stylistic jump provokes intriguing thoughts and one reads on. In *Moonstrips* Paolozzi often uses a long excerpt in one section, then has short passages from it sprinkled through other sections of text. In effect, this helps the reader further develop his scanning skill; the long passages create fairly complete mental sets so that subsequent brief flashbacks recall the whole and infiltrate the remembered mental flavour into the midst of a 'present' new context. Repeated scanning of such passages also makes the reader highly aware of the 'chemistry' of his memory which alters his sensitivity to various passages on successive readings. Paolozzi's collage text expresses powerfully in words what he calls the 'schizophrenic quality' of the modern life experience. There is a

high degree of wit, parody, and irony in the collage juxtapositions. For example, Paolozzi wickedly plays with the reader's habit of accepting the printed word as absolute truth by mischievously sprinkling throughout one section passages written by a wide assortment of 'I's. The amount of text on any one *Moonstrips* page is somewhat arbitrary. However, the fact that a certain set of passages is grouped on one sheet makes the reader endow them with a unit-coherence which heightens the reverberations between the component passages. Short excerpts from the *Moonstrips* text are less satisfying than brief quotations from many of Paolozzi's writings. For this reason, the complete text from one sheet is reproduced in Appendix C, page 133.

Since *Moonstrips*, writing has been an almost daily part of Paolozzi's creative activity. He has expanded the expressive possibilities of the collage writing technique while tightening his control of the style. For *Ambit 33*, 1967, he prepared an article 'Moonstrips — General Dynamic F.U.N.' The text is primarily a parody of the colourful writing style of the American popular press — *Time, Newsweek* — with an occasional excursion into slightly more serious publications like *Fortune* and *Scientific American*:

> With them he achieved New York, the acme of human effort. Power and light are its symbols and skyscrapers its phenomena. By day they make its magic and they turn its nights into cosmic melodrama. But here is a mob. Turnstiles are sometimes locked to dodge, run around each other and leap forward into the smallest open space, actual progress is slow. Everyone hurries, but moves more slowly than a man walking alone in a village street. But congestion seems the penalty of being a city. Deep chariot ruts in Pompeii's paved streets show that even the Romans battled with traffic.

In texts for two recent exhibition catalogues, Paolozzi makes marvellous collage-play with science-philosophy themes. One of the texts, 'Theories Concerning Aesthetic Chance and Neo-Platonism' (prepared for the artist's show in 1967 at the Rijksmuseum Kröller-Müller, Otterlo), opens with this section:

> According to Kant's theory, 'pure natural science' is not only possible; yet at the same time it retains the possibility of differentiating pseudo-concepts and pseudo-sentences from real scientific concepts and sentences, and thus of eliminating the former.' Here we find better products and complete integrated advanced systems for aero-space, defense, industrial, aviation, stainless quantities or pure numbers. Thus, eliminating all reference to our articificial human existence. But much contingency remains essentially unstable.

The second catalogue text, 'Analysis of Domains or the Spectrum of

111

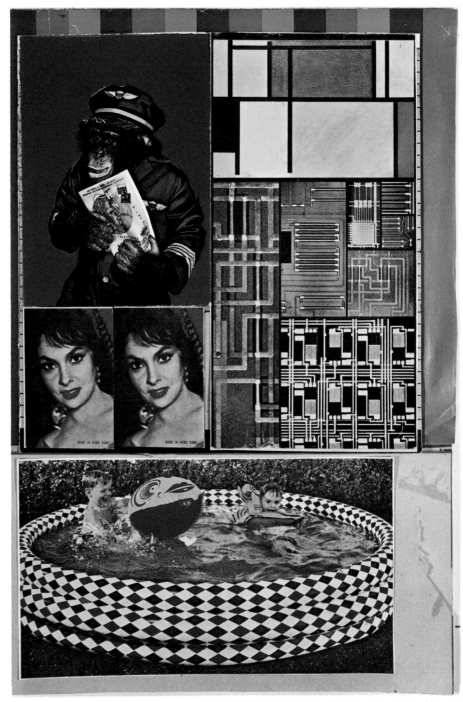

84 Collage for *General Dynamic F.U.N.: Gina Lollobrigida* 1968, 15 × 10 in. Collection the artist. Photolithograph and screenprint published by Editions Alecto, London, 1970

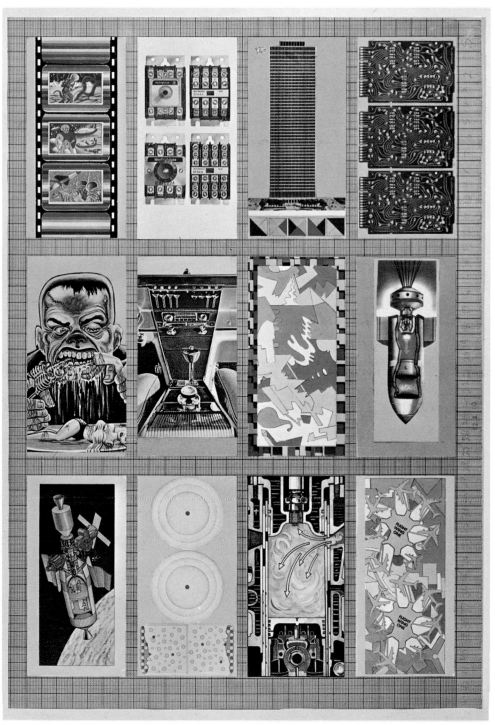

85 *Zero Energy Experimental Pile: Will the Future Ruler of the Earth come
from the Ranks of the Insects?* 1969–70 offset lithograph and screenprint
(edition of 125) 34 × 24 in.
Published by the Petersburg Press, London, 1970

Alternatives' (produced for the artist's 1968 exhibition in Düsseldorf, Germany), swings more widely between factual fragments and fantasy. The layout departs from the learned paragraph format and often resembles free verse (complete text reprinted in Appendix D, page 135):

During the past twenty-five years
many of the advances in differential
geometry of surfaces in Euclidean
space have had to excite the
admiration of their human observers
and exploiters.

'My house', says the bee in the
'Arabian Nights', is constructed
according to the laws of a most severe
architecture;
and
'Euclid himself could learn from
studying the geometry of my cells'.
Hegel's philosophy of identity, 'That
which is reasonable is real, and that
which is real is reasonable; thus,
reason and reality are identical'.

More recently, Paolozzi has edited some of his text into several short, more definite, collage poems. In the artist's plans for future written works are a philosophically-orientated sequel to *Kex* and a fantasy autobiography. As yet, collage, serendipity, improvisation, and chance are not 'acceptable' writing techniques. Neither are random stream-of-consciousness passages. Despite the extensive pioneering work of Roussel, the Dadaists, Surrealists, Joyce, and others, most readers still tend to dismiss such texts as suspicious tricks — essentially nonsense. But gradually as more and more writers use related methods, more readers will develop the ability to enter the 'new writing', and the enchantment and rich diversity of Paolozzi's texts will be more widely appreciated.

Paolozzi has recently also been exploring the artistic potential of various modern technological processes. In 1967 he planned a sequel to *Moonstrips* called *General Dynamic F.U.N.* (plate 84). The new box was intended to be an ironic critique of certain aspects of American materialism, and the images were almost all drawn from the pages of American magazines. (At one time glorified paperback format was considered: the final decision was for the *Moonstrips*-like box.) As work on the collages for *General Dynamic F.U.N.* developed, Paolozzi grew increasingly dissatisfied with the static image-collage as a medium for communicating the schizophrenic qualities of life. The images did express something of the multiple visual stimuli which surround the modern city-dweller. But they did not completely capture the sense of constant flow

and rapid change which is an equally prominent part of daily existence, and which the artist also wanted to express. So he turned once again to cinema as a medium for suggesting more of experience as man lives it in his mind. Paolozzi began planning a film version of *General Dynamic F.U.N.*, in which he hopes to combine live action and animated stills by linking the collages with scenes inspired by pictures in the collage-stills.

In his present search for ways to adapt technological processes into art media, Paolozzi has also been working with a sound technician on the *Universal Electronic Vacuum Sound Project*. The prototype model of this work has a radio circuit and a silver metal record enclosed in a transparent plastic box. When one opens the box (using the combination lock embedded in the lid), the radio circuit emits a steady sound whose pitch may be varied by a handy dial. The disc will contain a sound collage of auditory 'found objects' and of Paolozzi's voice reading a specially prepared text. In the spring of 1969, the artist also journeyed to California to participate in an Art and Technology Program initiated by the Los Angeles County Art Museum's Maurice Tuchman. At first Paolozzi worked at and with Wyle Laboratories in an attempt to devise a method of translating binary infraction into a means for artistic creation. The project, which got to a model stage, incorporated binary streaming of liquids under stress by polarization. Paolozzi envisioned a twenty foot square frame in which liquid patterns would be affected by motors, sounds, etc. Certain obstacles made the finalization of this project impossible at the time, so Paolozzi (with his assistant James Kirkwood) investigated several other possibilities with other firms in the Los Angeles area. Among them were Information International, where he experimented with the uses of a scanning head for scanning and storing information in computers, and Calcomp, where he expanded his knowledge of computer graphics and had the loan of a flat bed unlined plotter. Finally Paolozzi worked at TRW, Inc., Space Park, on a project which would involve using a computer to generate visual metaphors — thus adopting computer technology for a kind of philosophical activity. (This project is still in the stage of possible development.)

Out of his California experiences came much of the impetus for *Katzville,* an outsize book (to be published by the Petersburg Press, London) which will attempt to create the sense of a whole city. Originally *Katzville* (plate 87) was to be modelled on Los Angeles. Now, more probably, it will concern an imaginary metropolis. Paolozzi has been interested in the shape of cities since the early 1950s when he designed some sculptural environments and created a series of collages whose roughly rectilinear patterns suggested the grids of city plans. This early fascination with grids was reinforced in the years that followed by a continued obsession with skyscraper façades and an admiration for Mondrian's painting. Paolozzi now finds the grid system one of the most versatile for his work. The grids may be actual line scaffolding, based on a variety of

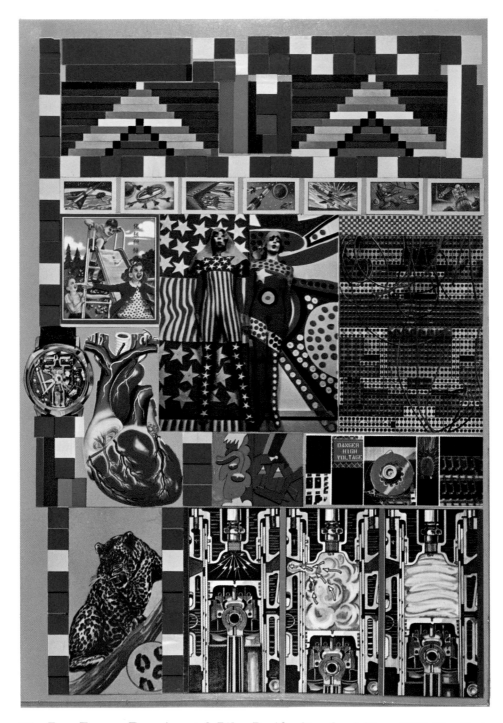

86 *Zero Energy Experimental Pile: Pacific Standard Time* 1969–70 offset
lithograph and screenprint (edition of 125) 34 × 24 in.
Published by the Petersburg Press, London, 1970

graphs or tables and enclosing fragments of collage text. The grids may be the invisible means of ordering a pseudo-map or a page of images. Or the grids may serve as the inspiration for a whole series of new transformation designs developed by the artist through photography, precise re-drawings, and colour photolithography. These 'skyscraper' pattern sheets are to be used as raw material for many of the *Katzville* collages.

At present Paolozzi is in mid-career. Already he has produced a body of work which has established him as one of the most important artists of his generation. In sculpture, drawings, collage, prints, and films, he has created mysterious and potent emblems of the modern age. Most of his works seem to be infused with special life. Of his whole sculptural *œuvre*, he has said: 'I've been trying to get away from the idea, in sculpture, of trying to make a Thing — in a way, going beyond the Thing, and trying to make a presence'. (Hamilton, *Contemporary Sculpture*) Presences occur in his graphic works as well. These images are usually concocted from assemblages of items from the everyday world, because,

> I suppose I am interested, above all, in investigating the golden ability of the artist to achieve a metamorphosis of quite ordinary things into something wonderful and extraordinary that is neither nonsensical nor morally edifying . . . the sublime of everyday life. (Roditi, *Dialogues on Art*)

To accomplish his aims Paolozzi has devised many techniques for presenting multiple layers of evocative imagery. His most characteristic designs are intricate and busy, like much of the earlier art he admires, from the paintings of Piero di Cosimo to the surfaces of oriental bronzes. These designs allow him to present the vast aggregations of everyday items which create the magical, evocative meanings of his works.

Much of Paolozzi's art has seemed to be in the current of art that was being produced at the same time in England, Europe, and the United States. But detailed comparison with other art is, for the most part, unrewarding, either for the understanding of his work or for that of others. Most of the apparent relationships between his work and contemporary art occur neither because he borrows from other artists nor because he influences them; they occur because of his mental 'radar'. Paolozzi's images are the product of his creative imagination which omnivorously ingests widely diverse stimuli from the world, passes them through the filter of his mind, and melds them into his living emblems. Such an image-maker is not likely to have the kind of influence on other artists that the inventor of a less personal art might have. For to follow Paolozzi's imagery would be to copy it. And his formal inventions are so inseparable from his imagery that to try to adapt the former would be either to copy the latter or to create truly lifeless works.

Some of Paolozzi's ideas and interests have pointed the way to later

117

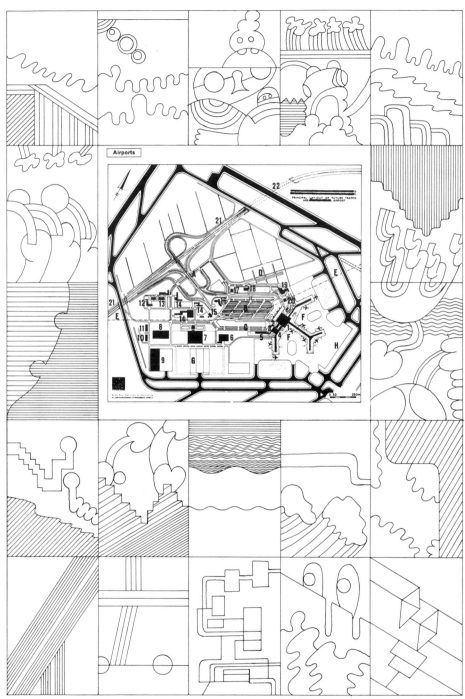

87 *Katzville M.I.J.* work in progress 1969–70 page size $17\frac{1}{4} \times 12\frac{1}{4}$ in.
To be published by the Petersburg Press, London

developments in the art world: for example, he was trying to use pop images in his work as early as 1952. Some of the techniques and styles he devised to express his ideas have also paralleled or prefigured work elsewhere. His early rough concrete works inspired many young sculptors to turn away from the polished surfaces of Moore and Hepworth. The experimental film he made with two friends in about 1954 incorporated some of the concepts which have become important to film-makers in the 1960s. His interest in colour screenprinting in the 1960s helped trigger a revival of interest in that art form in England. And his earliest chrome-plated steel pieces were among the first experiments with using that medium for sculpture.

However, the essential core of his art is not in these details of technique but in the final images and ideas he communicates with these methods. Some of his images may have loose links with other art, but even these are infused with the ineluctable, inimitable spirit of Paolozzi's powerful synthesizing vision. At present he seems to be in the process of again re-inventing his approach to his art. It seems inevitable that this artist will continue to probe for new (and unexpected) techniques to express his changing visions of the world around him.

Appendix A

'NOTES FROM A LECTURE AT THE INSTITUTE OF CONTEMPORARY ARTS, 1958'
Uppercase No.1

Key phrases, like key sculpture, take time to make. The arrival at a plastic iconography is just as difficult as a language. A few sculptures per year can alter other plastic values. A few key statements can have a similar effect.

It is my opinion that to talk of ART or, to be specific, modern sculpture, requires a special language:

Avoid using worn cliches, the words that can't even indicate or scratch at the hundred hidden meanings in objects & structures.

My own reading or source material is largely that of previous art works, technical magazines & books, a world of intricate problems and a lucid language.

Experiment, discipline seem to find their own system. Rational order in the technological world can be as fascinating as the fetishes of a Congo witch doctor.

The multi-evocative image demands a prose lyrical style at least. Anyway, an object which suggests a number of things might be described by the spectator in that order.

Certain expressions are affected by developments such as 'as far as the eye can see'.

SYMBOLS CAN BE INTERPRETED IN DIFFERENT WAYS.

The WATCH as a calculating machine or jewel, a DOOR as a panel or an art object, the SKULL as a death symbol in the west, or symbol for moon in the east, CAMERA as luxury or necessity.

Acid etched, copper plated, dipped in liquid solder, the printed circuit, intricate, complex, evocative, as pretty as a Fabergé jewel.

Modern polythene toys, due to the combination of plastic injection methods and steel dies, have a microscopic precision impossible to the handcraftsman of the past.

Giant machines with automatic brains are at this moment stamping out blanks and precision objects, components for other brains which will govern other machines.

120

Mechanics of living

MOUSETRAP continue

Trees with many faces

" IN MEXICO

Gunmetal

Railroad track flowers

With Citron Yellow

HAND
PRINTS

Argiopes
and alligators

Here is a list of objects which are used in my work, that is to say, pressed into a slab of clay in different formations. This forms an exact impression (in the negative of course) and from this a store of design sheets can be built up. They range from extremely mechanical shapes to resembling pieces of bark.

METAMORPHOSIS OF RUBBISH
Dismembered lock
Toy frog
Rubber dragon
Toy camera
Assorted wheels and electrical parts
Clock parts
Broken comb
Bent fork
Various unidentified found objects
Parts of a radio
Old RAF bomb sight
Shaped pieces of wood
Natural objects such as pieces of bark
Gramophone parts
Model automobiles
Reject die castings from factory tip sites
CAR WRECKING YARDS AS HUNTING GROUNDS

At the elbow, in wax form: a DIRECTORY OF MASKS, sheets of
an ALPHABET OF ELEMENTS awaiting assembly: boxlike LEGS
tube ARMS, square HEADS, copper WORDS, WHEELS like eyes
for symbols
GRAMMAR OF FORMS neo-geometric
ENCYCLOPAEDIA OF FORMS including non-FACE
ELEMENTS at the ready
DICTIONARY OF DESIGN ELEMENTS

My preoccupation or obsession with metamorphosis of the figure:
That is a CRACKED COLUMN resembling a PETRIFIED
 TOWER
DISINTEGRATING FIGURE with a SHATTERED HEAD
a CRACKED TOWER like a SHATTERED FIGURE
the METAMORPHOSIS OF A COLUMN INTO A FIGURE
INTO A TOWER A MAZE OF PARTS AND PERSONS
like an avant garde POWER PLANT

122

a remarkable lotion that

FOR

A

CANINE CHALLENGE

THE MOON STRIKES
DOWN
LATER, LIKE AN ARROW

P E O P L E

E Y E V I E W
O F

N E W Y O R K

B Y **PART**

Winter S U N Down to a Sunny Sea

TILTING HORIZON

news

Make It from a Pattern—
The Lean
Line in N E W S.

T R O P I C S

This is what I have in mind:
THE CLOCK AS A TOY
 Sites for imaginary ball games
 Slot slit

 Non-mechanical toys
 Mechanical non useful dolls
 Useful non useful Toyclock Toy Man
 Experience as a factor
 Projects for sites for Monuments
 A Fantastic
 Autobiography

A Biographical fantasy of a
Project of a hundred faces
A fantastic project for a playground
A Historical playground for fantastic people
A Battlefield of ideas
A Monument peopled by historic fantasies
Weep at monuments to
Fantastic weapons
Pathos
Psychological Atlas
Secret Map
Secret word
Unknown Frontiers
Mud language
Written with object trouve and broken toys
A sunken city empire town
The written word as a weapon
The word written is to weep
Cry out a language
Sea light Sun Wheel
Electric Sculpture
The magic Japanese Water language
Plugs London World
Supply Maps to a
Creative
The paradoxes
A world of shifting dissolving Horizons
A traveller in a hostile land
Ephemeral Tracings in the sand
Water signs and shadow language

PRINTED CIRCUIT
The process where SCIENTIFIC PHENOMENA become
 SIGNIFICANT IMAGES
 the ENGINE FORCE directing the construction of
 HELLISH MONSTERS
 where is MAGIC & INTUITION now?

PAUL KLEE
And is it not true that even the small step of a glimpse through
the microscope reveals to us images which we should deem
fantastic and over imaginative if we were to see them somewhere
accidentally & lacked the sense to understand them.

description of the creative process

The design sheets: A WORLD WITHIN A WORLD. A LANDSCAPE WITHIN A FACE. A RIDGE AND THREE MOUNTAINS SUGGEST A SMILE.

The objects USED are selected according to certain rules previously ordained by methods, useful in flexibility. & on a known range of possibilities. Certain quasi geometric shapes intrude up fierce projections resembling coke clinker or geological phenomena. The marriage of mixed elements. The design sheet either as a broken fragment or as part of a construction (figure)

Does then the artist concern himself with
Microscopy? History? Palaeontology?
Only for the purposes of comparison, only in the exercise of his mobility of mind.
And not to provide a scientific check on the truth of nature.

like an
archaic
Tower.

Worthy &
steadfast

Centre of
organic
interest

126

AS A PARODY OF
ZEN PROSE.

The names of different
parts of the sculptures.
 . ARE. ~~have names.~~
the legs — the utsama.

the Torso — the sumata

the head : the zohkoli.
 & arms.

 the Tools are
like the instruments in an
orchestra. to be played
with to form shapes & patterns

bamboo gongs are used
with the wind.

COMPLEX MICROSCOPIC WORLD LIVES IN THE MOUTH
 ANIMALS WITHOUT BACKBONES
ACCORDING TO SCIENTIFIC TRUTH
SAND WHICH IS CUSHIONED WITH THIN FILM OF
SEA WATER
HERE LIVES A WORLD THE SEASHORE MYSTERY
THESE ANIMALS FIGHT, DIE, REPRODUCE
LIFE OF AN INVISIBLE DIATOM.

DISINTEGRATE
An image is cut out of a newspaper; shall we say a blurred news
photo, flashlight taken in the rain, of a crashed aeroplane.
A battered wheel rises sharply in the foreground near a happy
face, a cowling like an eye waits in the vegetation.

Twisted and pulled still recognizable crashed JUNKER
part of the anatomy/fuselage exposed like a wounded beast
zinc-alloy piece filled with Scottish clay
Fragment of an autobiography

THE REDISCOVERY OF AN IMAGE CAN BE FORCED
UPON THE SCHOLAR LONG AFTER THE INITIAL
OPENING OF THE TOMB.
ASSYRIAN MUD LANGUAGE WRITTEN WITH BRONZE
OR WOOD STYLUSES INDICATE THE CAPACITY OF A
GRAIN WAREHOUSE.
CLAY TABLETS UNEARTHED IN A SUNKEN EMPIRE TOWN
ANONYMOUS FINGERS TRACE A PATTERN, UNKNOWN,
SOON TO BE SOLVED BY A JESUIT WITH A
CALCULATING MACHINE.

HEAD OF CYCLOPS
The amount of movie footage used on films based on Greek
mythology could be quickly assessed, though the assembly of
people thinly dressed in front of eroded Mediterranean islands
would be easier than M.G.M.'s Diane of Poitiers, or, say, The
Parson & The Cowboy.
The evolution of the cinema monster from Melies onwards is
necessary study for the fabricator of idols or gods containing
elements which press in the direction of the victims nerve-senses.

THE TOOLS.

BRASS FISH KNIVES
WIRED ONTO WOODEN HANDLES
SOLDERING - IRONS.
POTS.
GAS RINGS KITCHEN
STYLE

THE ACTION

BURN. CUT
MOLD MODEL.

CONSTRUCT. TACK
destroy & Reccombine

THE STUDIO AS KITCHEN OR
DEVILS KITCHEN

SCIENCE FICTION
It is conceivable that in 1958 a higher order of imagination
exists in a SF pulp produced on the outskirts of LA than the
little magazines of today.
Also it might be possible that sensations of a difficult-to-describe
nature be expended at the showing of a low-budget horror film.
Does the modern artist consider this?

BAS RELIEFS
A fossil fish made not by liquid rocks & millions of years but by
a punch on wood
Winter light shines on MARKS & SCRATCHES
 SPECIFIC SMEARS
 TECHNICAL TRACE of a
 BOX CAR IMPRINT
 PLASTIC
 BROKEN CABOOSE SHAPE &
 BENT CLOCK CHASSIS
A path is drawn with a giant finger
Here is an excerpt from a diary written in plastic ciphers
A temple ground lit by flares
A parade of political robots gone criminal

SAINT SEBASTIAN I
My occupation can be described as the ERECTION OF HOLLOW
GODS with the head like an eye, the centre part like a retina.
This figure can three parts be described in the use of a form of
principle of Architectural Anatomy.
A base containing the title, date and author in landscape letters.
The legs as decorated columns/or towers. The torso like a tornado
struck town, a hillside or the slums of Calcutta.
A bronze framework containing symbols resembling bent
mechanisms. An automata totally exposed, with ciphers.
A statement is printed on the back.

HEAD OF SAINT SEBASTIAN II
From the legs as columns and the torso as framework we shift to
the HEAD.
A dome, a shell. Partly bent under pressure.
Containing; but only superficially some kind of mechanism.
This might be described as anti-mechanism.

130

Appendix B

'MNEMONIC WELTSCHMERZ WITH PROBABILITY
TRANSFORMATIONS (A SYSTEMS STUDY)'
"*Universal Electronic Vacuum* "

We can easily imagine a world in which sticks behave
according to the rules of perspective, i.e. exactly as
they appear to behave to Haggenmüller. In presenting
a group of words, the same number of repetitions for
a given series, and the presentation time consequently
varied, being necessarily longer for spelling by letters
and transcription. With Itschner the presentation time
was elastic enough to include the unexpected, strong
enough to stand the shock of our necessary experiment
and in scenes of mixed actions, participated in by
beings of both kinds, indicate how those figures which
only we who look at the picture are supposed to see,
shall be so represented. The characters in the picture
shall not see them, or at least shall not look as if they
could not help seeing them, the whole series, as well
as many separate pictures, in the highest degree
confused, unintelligible, and self-contradictory.
The transfer disappeared, however, when cross
connections in the midbrain, as well as the corpus
callosum, were cut. Prep-school lad taking hot and
heavy notes while panels from Pensione Fioria, picture
of castration. Our patient had several nightmare
dreams dealing with the scene of being blinded. We
are also reminded of the patient's compulsion to push
pointed objects into his eyes. This instinctive expecta-
tion of finding regularities, which is psychologically
a priori corresponds very closely to the law of causality
which Kant believed to be part of our mental outfit
and to be *a priori* valid. But this tentative idea does
not work. For what interests us most is the empirical
content of an explanatory universal theory; yet from
such a theory alone no observational statement
follows. From 'All ravens are black' we thus came to
realize that in the four-dimensional continuum of
space-time only the coincidence of two world points,
'here-now', or their immediate vicinity has a directly
verifiable meaning. A stratification of this four-
dimensional continuum in three-dimensional layers

is simul-mined by joining distinct elements, without any bond other than the external cause constituting them, a constant pitch attitude is selected. The wing flies at near zero as perfect as possible, in accordance with faith, custom and law, and then to present them, to be withdrawn for ever from the eyes of man, to the dead, the demons, and the gods. We must be conscious of ourselves in the world in which we dance. The age of interior-power as symbols of the divine actors in the dragon story and the sun's movement. There were thousands of very drawable things in this new world. It was a problem not so unlike the problem I would face if I were a European artist, and Mr Marshall Field were to take me to the top of the Chrysler Building and, showing me America off to the west, say, 'Draw this. We go to press next week.' On this basis, however, the Germans have evolved a definite style. The long lines of the horizontal strips and windows, the contrasts being judiciously planned, are powerful and striking in effect. The same tone may be sounded with the different plexe Streben, die divergierenden Grundelemente des Bildes, in anderer Weise der Plastik, miteinander zu verschmelzen, wird womit umgriffen von dem komplexen Bemühen, selbst unausflösbare Extrem-Kontraste in einen möglichen Beziehungsraum zu stellen. This world, or of some of its aspects, and at a true explanation of observable facts; combines this doctrine with the non-Galilean view that though this remains the aim of the scientist, he can never know for certain whether his findings are a preoccupation with death; the same could be said of art. It is perhaps interesting to observe that Malevich identified himself with the non-objective (non-being) to such a degree that already during his lifetime he possessed his own coffin which he covered with suprematist painting. Mondrian insisted on a timeless art. Wave mechanics pictures a universe whose substance is probability, whereas classical mechanics pictures a universe whose substance is mass, energy, momentum, electric and magnetic force, etc. Some titles of my works are witness to the almost grammatical conventional space-time variables, but the solution itself is physically real. The Zo were accordingly represented as existing in the probability distribution or 'fog' whose history is being traced.

Note added to the proofs
When this paper went to press Albert Einstein was still alive, and I intended to send him a copy as soon as it was printed. My remark referred to a conversation we had on the subject in 1950.

Appendix C

TEXT PAGE
Moonstrips Empire News

Still another example of the naturalization of the clown is the modern play 'He Who Gets Slapped', likewise Hollywoodized. It is Tim who is being carried along by a swift current, the rescuer must brace and merely strive to hold until the body comes to a horizontal position. Once on the surface where the grip of the current is not so strong, the victim can be drawn to shore. If two people are present, one should always act as anchor for the other, holding him by the feet or one hand, of heat sealing. Most often I found in the industry is the simple hot plate type of sealer as it is cheap and effective. A thermosoftening plastic, placed between two hot plates will soften and fuse to itself — that's the idea, at any rate. Some plastics materials won't, however. Others, which are naturally soft, may tend to stick to the heating surfaces. In any case, a softening temperature may be critical to maintain through newspaper strikes and that's reading, but a strain on the eyes. In such an era, we feel bound to press forward to new 'first' such as packaging the package, and packaging the package that packages the package. However, We can still do it well, and remember that we need better choices rather than more choices, clearer and simpler openings rather than more different ones, and legible copy even when there has to be too much. Since the culture clock cannot be turned back, let us get on with the job quickly as life is short and the packaging art is long. — R.M.

. . . this anticipation is symbolic precipitation achieved through impatience or fear. In the criminology professor's case, since the murder takes place as the direct consequence of an indiscreet sex adventure, the dreamer is dominated by
ALBERT EINSTEIN
how little he or anyone knew. There was so much to learn if a man wanted to understand the universe. Now he studied not only his assignments, but everything rangement of parts, etc., yields to this simplest law, and which, in its directness and clearness, affords the simplest of working rules. Those whose artistic freedom bids defiance to the slavery of rule, as applied to an artistic product, and who try to produce something that shall break all rules, in the hope of being original, spend the greater part of the time in but covering the surface so that the principle may not be too easily seen, and the rest of the time in acting the unbalanced.

For a studio I was given the bedroom of the mother and daughter. The marble-topped dresser made a drawing board; the pair of dresser lamps gave me light by which to draw. The mother's rabbit fur slippers rested by my feet from my boots, and I wore, as a dressing gown, a woman's kimono, trimmed with fur.
The blue boat at the quay, the boatman ties planks on his feet. He falls into the water. Each of the musicians plays his favourite piece all together.

The police boat is upset. The musicians do not hear the signals. They think the voyage is mad and disorderly. El Greco had suffered headaches of late; black motes danced before his eyes eyes and objects seemed to swing and move when he knew that they were fixed. It was disconcerting, and he dared not paint when he felt a headache coming on. The Spanish apothecaries had no drugs to help him, so all he could do was wait out the attack. The pain, and the time lost at his work, made him irascible and bad-tempered.

'You shall be given all the aid and assistance our great city can offer and when you are perpendicular again you shall be photographed from any number of angles. And now, if you will allow me to, I should like to say a few words to my fellow-citizens.'

So the mayor removed his silk hat, which he handed to one of his committee of wise men, and, while he was being photographed in every possible attitude and from any number of angles addressed his fellow-citizens, informing them that Algebra had agreed to become perpendicular again and that he would be, as long as civilization lasted. It was a modern house, not unlike combination business and residence houses in smaller American towns. Part of the first floor was occupied by an up-to-date pharmacy, filled with the thousands of remedies against the German variety of headache and cold. There was a parlour with the kind of furniture you see in cheaper department stores in cities back home. Silver, candlesticks, and clocks were locked in the heavy sideboards — which were opened within a few minutes of our occupation. The upper floor had a sitting room and half a dozen bedrooms, furnished with rugs and floor lamps and toilet articles — things we hadn't seen for weeks. Correspondents need electricity for light by which to type their stories and play ornament. Even the Greek did not surpass it in the refinement

Appendix D

During the past twenty-five years
many of the advances in differential
geometry of surfaces in Euclidean
space have had to excite the
admiration of their human observers
and exploiters.
'My house', says the bee in the
'Arabian Nights', is constructed
according to the laws of a most severe
architecture;
and
Euclid himself could learn from
studying the geometry of my cells.
Hegel's philosophy of identity. That
which is reasonable is real, and that
which is real is reasonable; thus
reason and reality are identical.
If $X^1, \ldots X^n$ are n numbers, the points
whose coordinates form a very finely
ground material mixed with a trans-
parent substance then the light rays
with short wave lengths, the bluish
and reddish-blue, will be diverted,
and we are learning to recognize that
a hydrogen atom would not be what
it is, were it not the result of a selec-
tive operation performed on that maze
of interrelatedness which we call the
universe.
In Einstein's theory of relativity the
observer is a man who profits by
habitually combining an almost
universally accepted distinction and
a question-begging definition.
The distinction is between meta-
physical propositions on
the Unvertaintly Principle. A small
irreducible energy (or its equivalent

mass) is associated with any particle
in curved space. We can extend
this a little. I have no idea in what
part of the world you, my reader, live.
I might therefore describe your
uncertainty of position as tropos.

The two ends of the bow are brought
closer. We arrive at the equation. For
the behaviour of the universe which
(if the whole schema of relating
concepts or propositions) we suspend
the concept-basis relations of these
concepts and therefore their concept-
basis-thinker relations.
By asserting concept-basis
relationships, we suspend the
concept-basis-thinker relations of
these concepts and their bases.
If the organism functions normally,
recuperation from fatigue is possible
by (a) rest and (b) sleep, and first as
a preliminary stage of the second.
In sleep
the adaptive contacts with the outside
world are withdrawn; the muscle tone,
which always signifies readiness for
action, is reduced;
and to treat the material as though
it were gas. The practical threads —
the cloud caused by an exploding
shell in war!
To completable non-ostensive
concepts whose completions belong
to either of these two categories will
prove convenient. It will
somewhat have sharpened the face
of the waters when the world was made.

135

This explains why scientific myths,
under the pressure of criticism
become diverse so look out for
regularities, as we may see from the
pleasure of the child who satisfies
the need.
This 'instinctive' expectation of finding
regularities, which is psychologically
a priori, corresponds very closely to
the 'law of causality' which Kant
believed to be part of our mental
outfit and to be *a priori* valid.

Types of statement seems
unnecessary — even if it were
possible. In terms of communication
potential this does not appear to
matter. In the case of Pi being
different from oz, the formal
constructed as a well-formed
or meaningful sentence is a
physicalistic language which is quite
similar to those proposed in 'Testa-
bility and Meaning'.
The pictures of invisible actions
follow immediately upon pictures of
visible ones;
and in scenes of mixed actions,
participated in by beings of both
kinds, does not, and perhaps cannot,
indicate how those figures which only
we who look at the picture are
supposed to see,
shall be so represented that the
characters in the picture shall not see
them,
or at least shall not look as if they
could not help seeing them,
he makes the whole series, as well as
many separate pictures, in the highest
degree confused, unintelligible, and
selfcontradictory.
In the colour accord there is,
in particular, the expansion — of the
universe, the electron has virtually
been our comparison standard;
for the ordinary small-scale

are constantly related to the electron.
So in this way character of the
sexual scene causes its symbolization,
and even the act of emission is
expressed symbolically
as an explosion.
In the distance it merges into a
sea of mist, white, motionless,
shadowless, and beyond lies
a low, dark ridge, almost dead straight,
like the edge of some nocturnal
highland.
It is quite otherwise
if we try to keep to our overlapping
exemplifications of 'visual circle' and
'visual ellipse' and add the rule
to the effect that the conjunction of
the two concepts is not
applicable to any basis. This would
be to give ourselves
a contradictory set of being traitors.
Thanks to paradoxes
the antidogmatic attitude has
disappeared, and Marxism has
established itself as a dogmatism
which is elastic enough, by using the
dialectic method,
to evade further attack.
It has thus become what I have
called a reinforced dogmatism.
In the colour accord there is,
in particular, the expansion — of the
universe, the electron has virtually
been our comparison standard;
for the ordinary small-scale standards
of length
are constantly related to the electron.
So in this way blotches, like spots,
are for the most part symmetrically
disposed.
But there are some interesting
interpretations. Fire will certainly
come upon all thinks; but upon each in
turn, not upon all at once
It will adopt the suicide policy of
destroying its means of nourishment,
which will only hold out if it consumes

136

them gradually
and at the same time renews,
if it recedes as far as it has
encroached.
In everyday life the question always
concerns the colour of the thing,
the colour that the object actually has.

The optical dreamer sees 'people',
and then the 'help', the latter an
allusion to the 'house', then sees
the friend's sister (read: 'patient's
sister') in the 'nude'.
The tabooed
systems of reference form the
group of 'physical automorphisms';
the laws of nature are invariant
with respect to the recognition.
In contrast, physiological optics is
concerned with colour itself, even if
only in the sense of the third meaning
of the word, namely as a sensation
datum, as appearance colour.
Here, black is something positive,
as it is also in art;
what makes this and many similar
skyscapes seem so real is a second
stratum of cloud that hangs over it
darker and denser.
Above the horizon of early morning
is a deep veil of mist, completed into
ostensive concepts which belong to
categories 'physical object' or
'physical process'. The
binding that is lying there on the
table; both would have the colour
of childhood fixations. The narration
then goes on
Above the door the patient sees
an inscription
welcoming him and wishing him
a good time inside.
This is observed as a regression
from the 'frustrated'
Oedipus level to the relatively
'unfrustrated' anal erotic level.
The interpretation infers that the

patient, whose regression
with Thales is that he foretold
the eclipse of the sun, which put an
end to the war between the Lydians
and the Medes. Now

we have every reason to turn
into the wind and land on one of the
slopes, taking care to do no injury
to the passengers, it meant sacrificing
the machine, but there was no help
for that.
One might thus
be inclined to say
that Kant failed to distinguish
between psychologic — only with
the complementary pairs but
with all 'triads' or 'tetrads' that
are achieved through some regular
trisection or quartering of the
colour circle. And so that what Goethe
called the 'characteristic' colour
combinations would not be missing,
Oswald has included 'unilateral pair
accords' and 'unilateral triad
accords' in which one of the three
or one of the four colours that are
obtained by triangulation or quartering
of the colour circles is left off.
In something selected from an always
present universe, often selected or
segregated experimentally, and in any
case selected in our thoughts.
Continued observation will
undoubtedly reveal other important
facts concerning circling, whirling, and
the periodicity of dancing, not to
mention the inheritance of
peculiarities of dancing and the
significance of the various forms of
activity
'Behaviour' plays an all-important
part.
Be they never so protectively coloured,
it avails them nothing unless it be
accompanied by a habit of repose
when resting — the only time when

this coloration is of real service.
To ourselves which although it must
be elastic enough to include the
unexpected, shall primarily be strong
enough to stand the shock of our
necessary experiment and our
inevitable mistakes.
We must be conscious of ourselves
in the world in which we dance.
The age of interior-power as symbols
of the divine actors in the dragon
story
thrown back, and scattered by these
tiny particles; while the longer wave
lengths, reddish-yellows and yellowish-
reds, pass through.
For this reason every philosophy are
socially organized means and methods
to influence and control the forces to
the propitiousness of which men
ascribe their welfare and prosperity.
A picture of the world answers this
question with varying, fugitive
appearance colours.
Those who accept this next best
answer — one or another of the
appearance colours — fall into a bad
and, in the trade, often expensive
error.

KIND OF COLOUR OR SPECIES OF
COLOUR If we want to determine
what colour this cube really has then
we use the word colour in the new
sense again. We could say, perhaps,
that the colour of the cube is 'the
same' as that of the blue calf.
No doubt it is a psychosis which has
only a short duration, which is
harmless and even performs
a useful function, which I have
described in the last section. I cannot
stop here to straighten out the tangle,
so will simply say that 'from a certain
of view m_0' is the mass of the
universe.
But this is not at all in accordance
with observation, in the Pleiades the
stars range over at least 10
magnitudes — indicating a wide
diversity of mass. Full grown,
and have reached their predestined
height. Now all is still, the
pointed summits stand
motionless against the blue. Only one
tiny cloud detaches itself from one
of the monsters and drifts away, as
though impelled by some unsatisfied
desire.

London 1968

138

Bibliography

PUBLICATIONS BY PAOLOZZI

'Notes from a Lecture at the Institute of Contemporary Arts,' *Uppercase No. 1* London 1958, unpaginated

Statement in Peter Selz *New Images of Man* Museum of Modern Art, New York 1959, p. 117

'Mein Diktionär', *Blatter + Bilder* Würzburg, March–April 1960, pp. 44f.

Metafisikal Translations Kelpra Studio Limited and Eduardo Paolozzi, London 1962

'Artist's Statement', Michael Middleton *Eduardo Paolozzi* Methuen, London 1963, unpaginated

'Notes by the Sculptor', Lawrence Alloway *Metallization of a Dream* Lion and Unicorn Press (Royal College of Art) London 1963, pp. 5f.

'Wild Track for Ludwig The Kakafon Kakkoon laka oon Elektrik Lafs',

text for *As Is When* portfolio of screenprints, April 1965

Kex edited by Richard Hamilton, printed by Percy Lund Humphries and Co., Ltd for William and Norma Copley Foundation, London 1966

'Mnemonic Weltschmerz with probability transformations (a systems study)', text for *Universal Electronic Vacuum* portfolio of screenprints 1967

Moonstrips Empire News printed by Kelpra Studio for Editions Alecto, London 1967

'Moonstrips — General Dynamic F.U.N.', *Ambit 33* London 1967, pp. 7f.

'Theories Concerning Aesthetic Chance and Neo-Plasticism', catalogue, Paolozzi exhibition, Rijksmuseum Kröller-Müller, Otterlo, Holland, 7 May–2 July 1967

'The Body as a Tool for Grasping Reality: Extracts from "Moon Strips E. News. The Story of Dot Zero" a work in progress by Eduardo Paolozzi', *Ark 42* 1968 (Journal of the Royal College of Art, London) pp. 37f.

'Analysis of Domains or the Spectrum of Alternatives', catalogue, Paolozzi exhibition, Städtische Kunsthalle, Düsseldorf, Germany, 19 November 1968–1 January 1969

Abba Zaba edited and printed by Hansjorg Mayer and students at Watford School of Art 1970

FILMS BY PAOLOZZI

The History of Nothing 1960–62
Kakafon Kakkoon 1965
Candles in progress
General Dynamic F.U.N. in progress

INTERVIEWS WITH PAOLOZZI

'Metamorphosis of rubbish — Mr Paolozzi explains his process', *The Times* London, 2 May 1958

Edouard Roditi 'The artist sketches an aesthetic of the *objet trouvé* based on a conscious metamorphosis of the derelict', *Arts* New York, May 1959, pp. 42f. Republished in *Dialogues on Art* Secker and Warburg, London 1960, pp. 152f.

Richard Hamilton 'Interview with Eduardo Paolozzi', *Contemporary Sculpture, Arts Yearbook 8*, New York 1965, pp. 160f.

BOOKS ON PAOLOZZI

Lawrence Alloway (in collaboration with Eduardo Paolozzi) *Metallization of a Dream* Lion and Unicorn Press (Royal College of Art), London 1963

Michael Middleton *Eduardo Paolozzi* (Art in Progress Series, edited by Jasia Reichardt) Methuen, London 1963

ARTICLES ON PAOLOZZI

Lawrence Alloway 'Eduardo Paolozzi', *Architectural Design* London, April 1956, pp. 132f.

—— 'Paolozzi and the comedy of waste', *Cimaise — art et architecture actuels* Paris, October-November-December 1960, pp. 114f.

Luigi Carluccio 'A Sculptor: Paolozzi', *Siderexport No. 2* (foreign supplement of *Rivista Italsider*) Genoa, June 1963, pp. 14f.

Rolf-Gunther Dienst 'Eduardo Paolozzi', *Das Kunstwerk: The Work of Art* Stuttgart, October 1962, pp. 16f.

—— 'Paolozzis Konstante der Erfindung', catalogue, Paolozzi exhibition, Städtische Kunsthalle, Düsseldorf, Germany, 19 November 1968–1 January 1969, pp. 8f.

'Eduardo Paolozzi', *244 no. 2* (Journal of the University of Manchester Architecture and Planning Society) winter 1954, unpaginated

Christopher Finch 'Paolozzi in the Sixties', *Art International* November 1966, pp. 25f.

—— 'Language Mechanisms', *New Worlds* (London) August 1967, pp. 28f.

—— 'Spotlight on Moonstrips Empire News. Eduardo Paolozzi's Dialogue with The Mass Media', *Vogue* August 1967, pp. 62f.

—— 'Moonstrips Empire News', text for publicity release for Alecto Gallery, London, summer 1967

—— 'Universal Electronic Vacuum', text for publicity release for Alecto Gallery, London, October 1967

—— 'The Paolozzi Mix', *Art News* February 1969, pp. 32f.

Robert Melville 'Eduardo Paolozzi', *Horizon* (London) September 1947, pp. 212f.

—— 'Eduardo Paolozzi', *Motif No. 2* (London) February 1959, pp. 60f.

—— 'Eduardo Paolozzi', *L'Oeil* May 1960, pp. 58f.

Jasia Reichardt 'Paolozzi and what led up to a certain event in 2000 AD', *Metro 8* (Milan) January—March 1963, pp. 78f.

—— 'Eduardo Paolozzi', *London Magazine* March 1963, pp. 38f.

—— 'Eduardo Paolozzi', *Studio International* October 1964, pp. 152f.

Karl Ruhrberg 'Introduction', catalogue, Paolozzi exhibition, Städtische Kunsthalle, Düsseldorf, Germany, 19 November 1968–1 January 1969, p. 3

Uwe M. Schneede 'Eduardo Paolozzi', *Das Kunstwerk: The Work of Art* November–December 1967

David Sylvester 'Foreword', catalogue, Kenneth King, Eduardo Paolozzi and William Turnbull exhibition, Hanover Gallery, London, 20 February– 18 March 1950

—— 'The Critics' Prize 1952', *Britain Today* February 1953, pp. 34f.

Index